the KODAK Workshop Series
Electronic Flash

D0515418

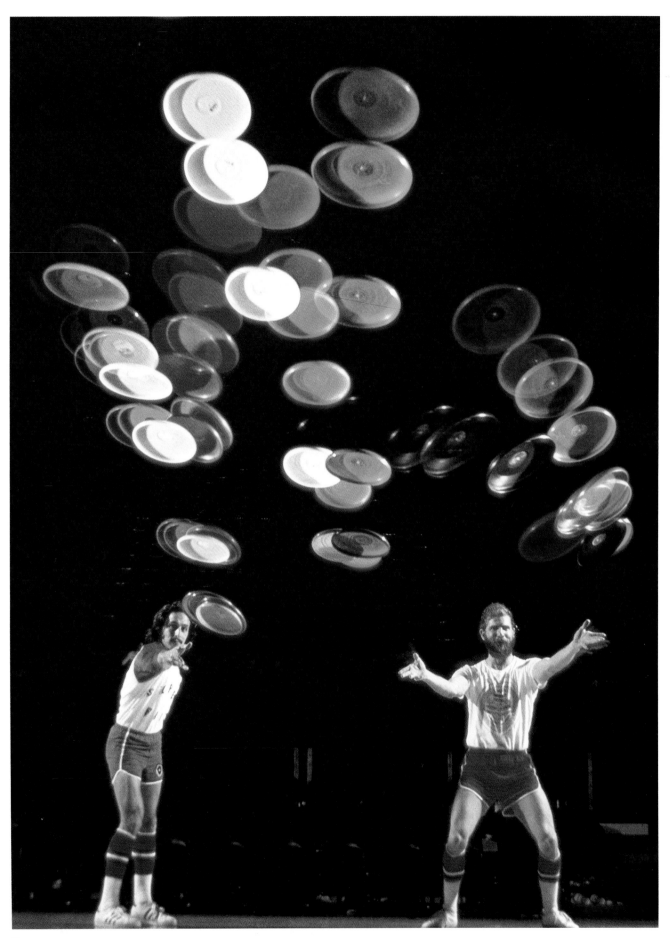

the KODAK Workshop Series

Electronic Flash

Written for Kodak by Lester Lefkowitz

the KODAK Workshop Series
Helping to expand your understanding of photography

Electronic Flash
Written for Kodak by Lester Lefkowitz

Kodak Editor: Martin L. Taylor

Book Design: Quarto Marketing Ltd.,
212 Fifth Avenue,
New York, New York 10010

Designed by Roger Pring

Illustrations by freelance photographers Steve Labuzetta and
Jerry Antos with contributions from Kodak staff photographers
Donald Buck and Bob Clemens and freelancer Bill Paris.
Exceptions are found on the following pages:

Page 2, John Zimmerman
Page 8, Tom McCarthy
Page 17, Roy Morsch

© Eastman Kodak Company, 1981

Consumer/Professional & Finishing Markets
Eastman Kodak Company
Rochester, New York 14650

Kodak publication KW-12
CAT 143 9850
Library of Congress Catalog Card Number 81-66623
ISBN 0-87985-271-2
12-81-GE New Publication
Printed in the United States of America

Throughout this book Kodak products are recommended.
Similar products may be made by other companies.

KODAK, EKTACHROME, KODACHROME, KODACOLOR, and
WRATTEN are trademarks.

This KODAK Workshop Book leads you with text, pictures, and concise caption text from the fundamental steps of electronic flash photography to a magic world that includes studio lighting control, multiple exposures, nature close-ups, sports, and much more. Spend a few minutes browsing through the book, savoring the possibilities that await you. Then start with page 8 and begin taking the flash pictures you've imagined in your mind's eye.

This graceful leap was silhouetted against a magnificent sunset with the high speed of electronic flash. (See pages 74-80 and 90-93 respectively for information on fill-in flash and action photography.)

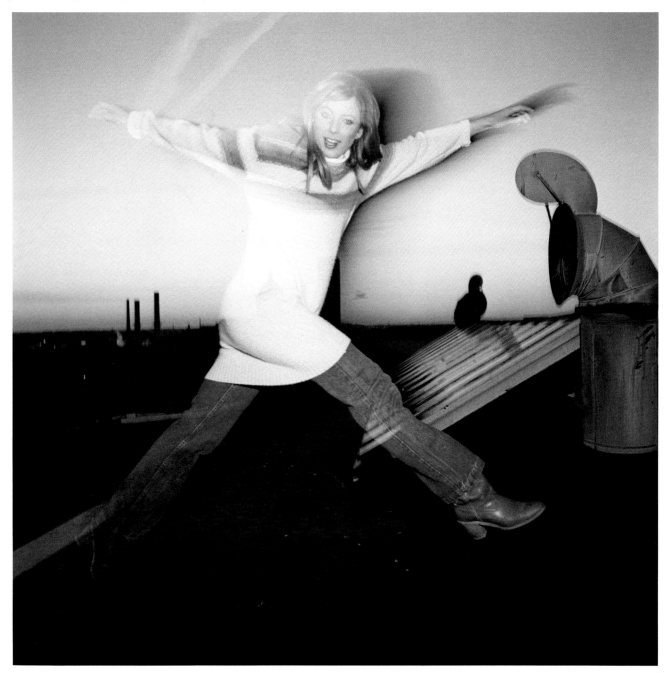

Contents

Table of Contents **Page**

Flash can do it! 8
How electronic flash works 14
Getting started 18
Important preliminaries 20
Basic operation 26
 Difficult situations 39
 Flash with other lenses 42
Basic off-camera operation . . . 46
 Off-camera flash 47
 Bounce flash 49
 Bouncing into umbrellas 54
 Bare-tube flash 57
 Flash meters 58
 Diffusion 58
Multiple flash 62
Flash outdoors 74
 Fill-in flash 75
 Flash outdoors at night 81
 Painting with light 83
 Flash and filters 84
Close-up flash photography . . . 86
Freezing motion 90
 Stroboscopic effects 93
Recommended reading 94
Index 96
Equivalent measurements 96

The short duration of electronic flash can record scenes foreign to the eye, such as the deep wall of water surrounding the cannonballer at right.

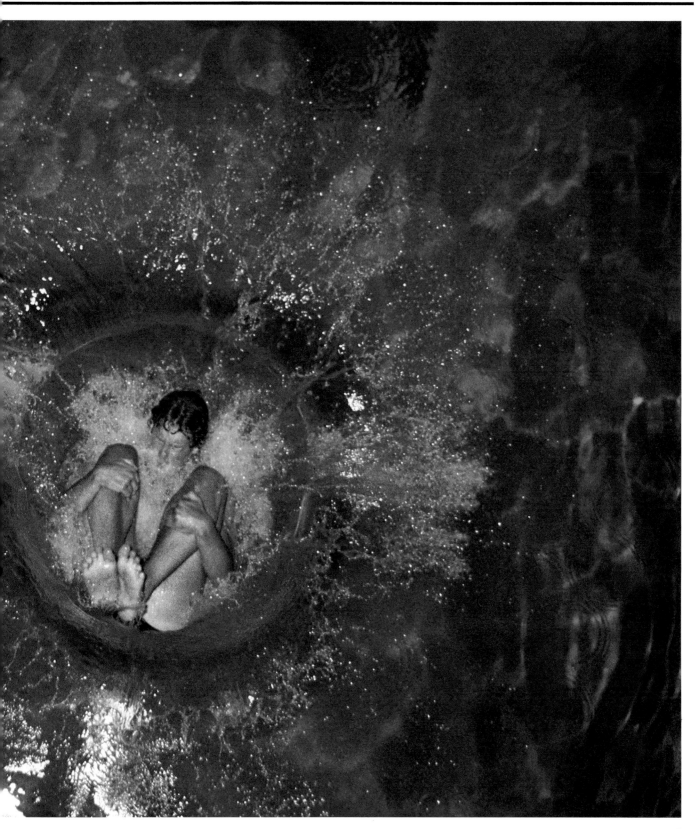

Flash can do it!

Flash! Bright light! Or perhaps the sudden illumination of an idea. Which is what flash photography is all about. By adding an electronic flash unit to your photo equipment you can bring your own light to the subject. Most flash units are lightweight, inexpensive, and powerful. They allow you to brighten almost any subject with total disregard for the ambient light. Moreover, the duration of the flash is short enough to freeze fast-moving subjects. And since you control the direction, quantity, and quality of the scene lighting, you can practically guarantee the results you want. *Action! (See page 90.)*

Reflected from a white card, flash can provide a soft, directional illumination. (See pages 49-55 for bounce flash.)

Flash positioned off the camera gives the subject a more natural and three-dimensional appearance. (See pages 46-48 for off-camera flash.)

Flash light bounced off the ceiling will cover a larger area than a flash fired directly at the subject. (See page 49 for bounce flash.)

Right: *With two flash units you can create the illusion of natural lighting. Use the second flash to fill in shadows created by the first. (See page 62 for multiple flash.) At* **far right** *observe the effect given by four flash units.*

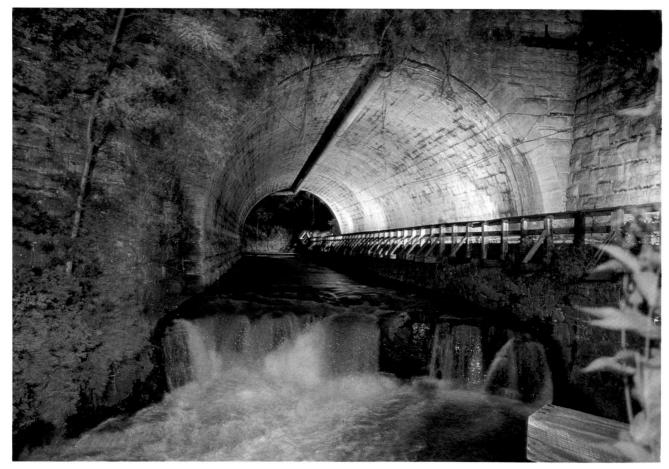

With one flash unit and some patience, you can record a large subject like this tunnel. (See page 83 for painting with flash.)

Attach an acetate color filter to the flash and a complementary filter to the camera lens, and you'll get unusual effects for nearby subjects and normal colors in the background. (See page 84 for flash with filters.)

When facing the shadow side of a subject outdoors in daylight, count on your flash to brighten the dark spots for extra illumination. (See page 74 for fill-in flash.)

Keeping the shutter open but covered between flashes, fire your flash several times in darkness to create intriguing images.

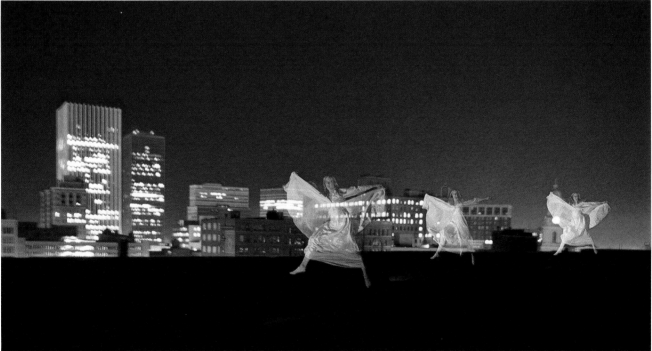

How electronic flash works

You press the shutter release and for an instant, all is bright. Taking flash pictures can be relatively simple—the technology is sophisticated. Knowledge of how electronic flash functions can help you appreciate the power, speed, and flexibility of your unit. Understanding the limitations may improve your results.

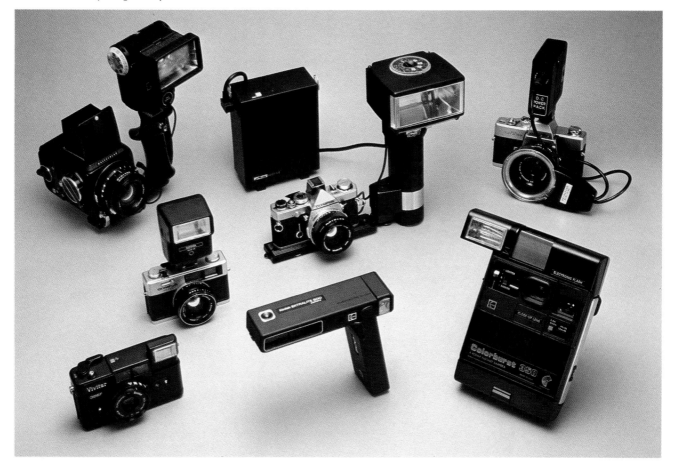

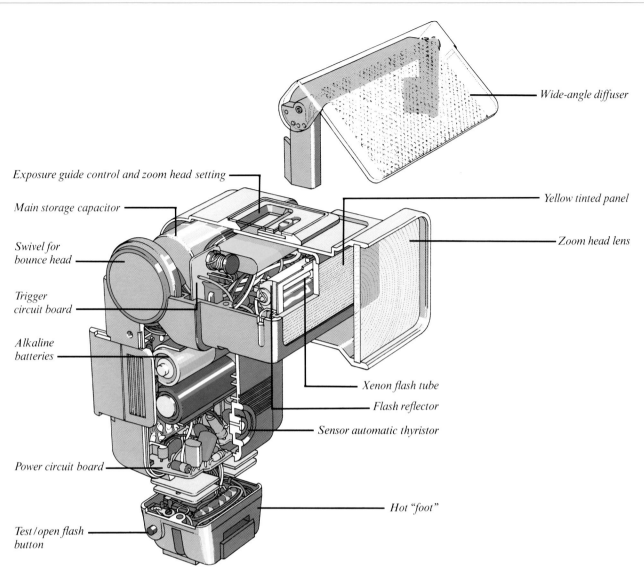

Wide-angle diffuser

Exposure guide control and zoom head setting

Main storage capacitor

Swivel for bounce head

Trigger circuit board

Alkaline batteries

Power circuit board

Test / open flash button

Yellow tinted panel

Zoom head lens

Xenon flash tube

Flash reflector

Sensor automatic thyristor

Hot "foot"

Despite the unnerving complexity of a flash unit's innards, modern-day flash is easy to use, sophisticated, and versatile. Automatic units even give exposure assistance.

HOW IT WORKS

Most electronic flash units consist of a flash tube set into a reflector, a battery or batteries, a capacitor that accumulates and holds a charge of electricity, and a network of electrical connections that enables the flash to go off on command.

When you trip the camera shutter, a switch within the camera is closed, completing an electrical circuit that simultaneously fires the flash. When the flash goes off, electrical energy stored in the capacitor releases in a sudden burst of power—converted to a flash of light by the flash tube.

The flash tube has an extremely long life expectancy. It can fire thousands of bursts before wearing out. Its burst of intense light is so short (usually 1/1000 of a second or faster) that fast action can be easily frozen in most picture-taking situations.

With the flash mounted in the camera hotshoe and switched on, you press the shutter to complete the circuit and fire the flash.

AUTOMATIC FLASH UNITS

Some advanced electronic flash units have the ability to vary and control the duration of light output. These units automatically adjust their flash duration for proper exposure. Automatic units have a sensor that measures the intensity of flash reflecting from the subject. When the light is bright enough to produce an acceptable exposure on the film for a pre-selected *f*-stop, the unit will halt its flow of light.

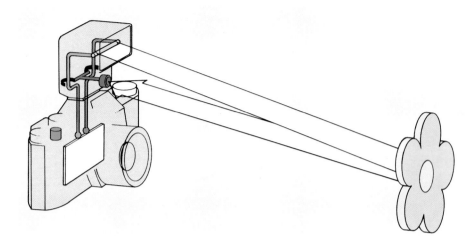

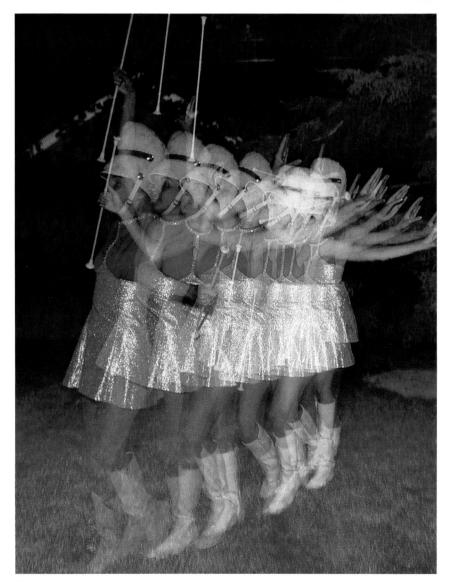

A sensor on the flash unit cuts off the flash when enough light has been provided for adequate exposure.

Many auto units will provide extremely fast recycling times when operated in the motorwinder mode or the mode requiring the largest aperture. This photo is a multiple exposure made with a sensor automatic unit. The photographer held the shutter open and fired the flash several times as soon as it recycled. The dark surroundings avoided the possibility of ghost images.

The viewfinder of a camera with dedicated flash capability often shows flash information, perhaps including an LED or LCD recycle light, a confidence light that indicates adequate exposure, and the correct shutter speed for synchronization, if necessary.

DEDICATED FLASH

Other automatic units—dedicated flash—work in conjunction with specific cameras to produce acceptable exposure. Although dedicated camera/flash outfits vary, a sophisticated system would work this way: When the shutter is released, the flash fires. A sensor, located in the camera behind the lens, determines the light necessary for correct exposure, sends the information back through the camera to the flash unit, and turns off the flash.

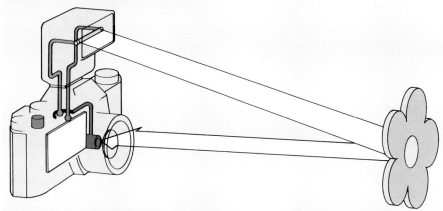

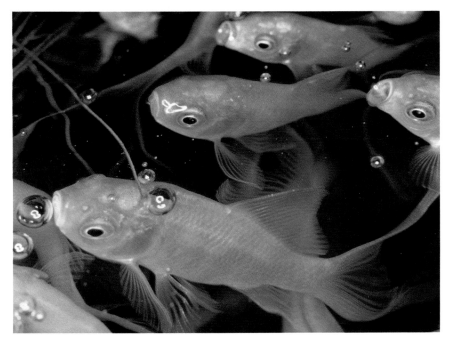

With the latest dedicated flash systems a sensor located at the film plane in the camera measures light admitted through the lens and cuts off the flash through circuitry connecting flash and camera. The accuracy of such a system is remarkable and is especially adaptable for such demanding subjects as close-up nature subjects and off-camera flash photography. The fish photographed from a close distance at left were captured with a dedicated flash and camera system.

17

Getting started

With a few easy steps, you can start right out taking high-quality flash pictures. This next section gives you the ground-level fundamentals. Once you're comfortable with your flash unit and its operation, stride farther to master more of the techniques that make flash photography a necessary addition to your storehouse of photographic skill.

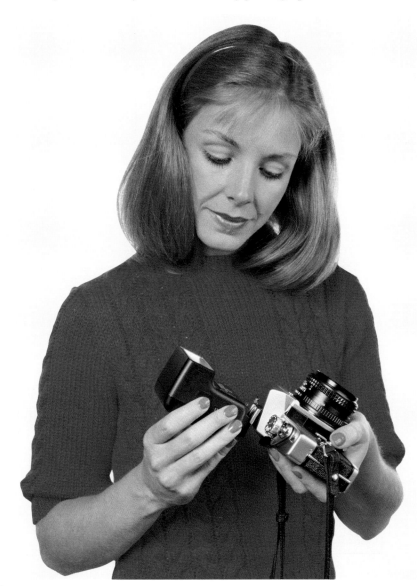

1. Attach flash to camera. If attaching the flash doesn't complete the electrical circuit through a hot shoe, plug the flash cord into the flash and into the camera socket. If you have more than one socket, use the one marked "X". Batteries should be fresh or freshly charged.

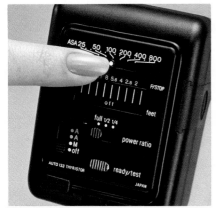

2. Set the film ISO/ASA speed of daylight film on the flash and/or camera. Set the flash for manual or auto if there's a choice. On a sensor automatic flash unit, set the appropriate flash range.

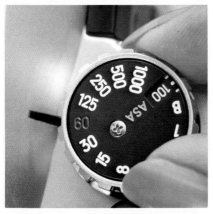

3. Set the recommended shutter speed.

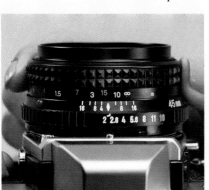

4. Focus—your subject should be within the maximum/minimum flash range.

5. Set the aperture, whether the camera is dedicated automatic, the flash is sensor automatic, or the flash/camera combination is manual.

6. Turn on the flash. Wait a little longer than it takes the ready light to come on. (The ready light tells you when the flash has enough power stored up to make a well-exposed photo. It is usually a small, orange panel that glows when the flash is ready for use.)

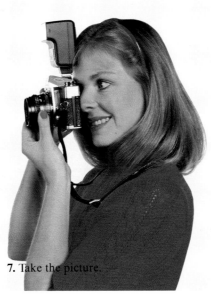

7. Take the picture.

TEN TIPS AND REMINDERS

1. Change or charge batteries when recycle times are 50% longer than manufacturer specifies for fresh batteries.

2. Set the film ISO/ASA speed on the flash and/or camera every time you take flash pictures.

3. The camera shutter speed *must* be set as recommended in the flash instruction manual.

4. If the accessory shoe on the camera is not electrically connected—not hot—plug your flash into the X outlet on the camera body. If there is a single socket and a synchronization switch, choose the X position on the flash synchronization switch. Newer cameras have either a hot shoe or a single socket for electronic flash.

5. Wait a little after the flash ready light comes on for full flash power.

6. Focus accurately on your subject for sharpness and correct exposure with manual flash units.

7. With automatic units operated by a sensor, the aperture indicated on the flash range/mode selector must agree with the aperture set on the camera lens.

8. With automatic units of any kind, make sure your subject is within the maximum/minimum range for the selected aperture.

9. Remove batteries when storing a flash unit.

10. When storing your flash unit, both batteries and capacitor should be fully charged.

Important preliminaries

*Modern cameras and electronic flash units are capable of producing fine photographs. To achieve success from the beginning, however, it's important to pay careful attention to a few easy-to-understand details concerning **1) energy supply, 2) maintenance,** and **3) operating controls of flash and camera.** The following chapter is devoted to these mechanical/electrical concerns.*

While the basic theory and operation of all electronic flash equipment is quite similar, there are considerable minor differences in physical features among different models. It is important that you carefully read the instruction manuals for both flash and camera. (Misplaced instruction manuals can almost always be replaced by a request to the equipment manufacturer or national distributor. The address is usually obtainable from local camera stores.)

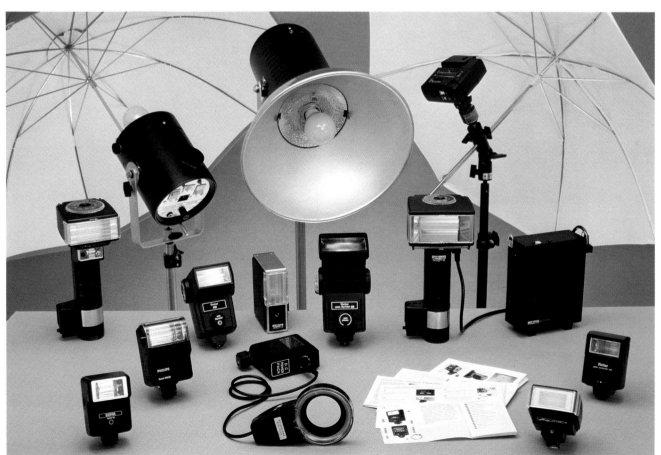

ENERGY

The heart of an electronic flash is its power supply. Batteries are generally relied upon as the primary, convenient portable source of energy. They do require some care and attention and should be the first item to check when the flash is not working properly. An understanding of battery characteristics is important when selecting equipment for your particular application.

Three Battery Types

Flash equipment is generally powered by either low-voltage disposable alkaline batteries or by rechargeable

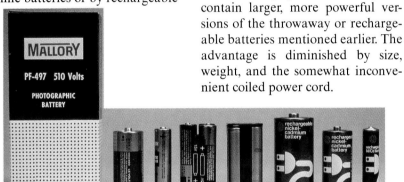

nickel-cadmium energy cells. Typically, two or four AA- or C-size cells comprise the self-contained energy source for a camera- or handle-mounted flash. For most consumer applications or light-duty use by a professional, these relatively small batteries provide more than enough flashes.

When a great deal of portable flash photography is required, economics and consistently fast recycling times make the **external battery pack** an important accessory. Available for most professional and top-of-the-line consumer equipment, these packs contain larger, more powerful versions of the throwaway or rechargeable batteries mentioned earlier. The advantage is diminished by size, weight, and the somewhat inconvenient coiled power cord.

The high-voltage pack generally draws from a 510-volt battery, which provides recycling rapid enough to use an autowinder or motor drive.

External battery pack.

Left: high-voltage battery for external battery pack. ***Center 3:*** *disposable cells.*
Right 4: *rechargeable cells.*

GENERAL CARE AND USE

Regardless of the batteries you select, some general comments pertain to all types used for flash equipment.

1. To get the freshest cells, purchase them from a retailer who has a rapid turnover in battery stock. If possible, check them on a battery tester.

2. Store batteries, including those in the flash unit, away from hotspots such as heating ducts, radiators, or car interiors and attics during the summer. Shelf life of throwaway cells can be extended considerably through refrigerated or frozen storage in a plastic bag. Allow refrigerated batteries to reach room temperature before installing them in your equipment, to prevent condensation from damaging the electrical components.

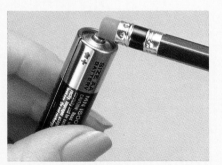

3. Remove batteries from the flash if it will not be in use for a few weeks. And to avoid short circuits, do not store cells in metal containers.

4. Keep the flash turned off whenever possible to prevent unnecessary battery drain. (A common cause of dead batteries is an on/off switch accidently turned on by jostling in a camera case. Either tape the switch in the off position, or remove batteries.)

5. Clean terminals of low voltage batteries as shown at left.

6. The best way to test a battery is with a battery tester. Otherwise, install it in the flash unit and note the recycling time after reforming the capacitor. (See page 22.) If it is 50 to 100% longer than the flash manufacturer specifies for fresh batteries, replace or recharge cells, whichever is necessary. It is impossible, however, to determine exactly how much life is left in any given battery, even though it may operate well when tested. It's always smart to have fresh spares at hand.

Rechargeable Batteries require careful attention! For instance, did you know that they are more inclined to expire—permanently—if not used than if used every day? Since there are considerable differences in the recommendations for charging, care, and use among various brands of nickel-cadmium batteries and charging equipment, it is imperative that you read and follow manufacturer's specific instructions. The following general guidelines apply to all rechargeable batteries:

1. Rechargeable batteries require periodic use and charging. Fire the flash a number of times at least every month (after fully charged), then fully recharge the batteries.

2. Store rechargeable batteries in a fully charged condition.
3. If discharged too much, some rechargeable batteries may never again hold a charge. When recycling time becomes twice normal, recharge the batteries.
4. Slow charging is easier on batteries than fast charging. If your charger provides a fast/slow option, use slow when possible. Additionally, do not put *any* rechargeable battery into a rapid charger; not all rechargeable cells can be safely quick-charged.
5. Since rechargeable batteries provide fewer flashes per charge than throwaway batteries, consider keeping a fully charged spare set on hand.
6. An external charger and a spare set of rechargeable batteries is a useful, relatively inexpensive accessory. This combination permits one set of cells to be rejuvenated outside the flash while the other set is in use. An electronic flash can charge batteries or make flashes, but usually not both at the same time.

AC Operation When you want to take many flash photographs in a fixed location for studio, portrait, scientific, or industrial applications, a more convenient, less expensive, and frequently more reliable alternative to batteries is the ac adapter. Available for all but the least expensive flash units, these small transformers convert wall-outlet current to the voltage required by the flash equipment.

An ac adapter usually provides a recycling rate similar to that offered by alkaline batteries. This inexhaustable source of power, however, may tempt one to fire the unit at full power in rapid succession for long periods of

time. Such abuse will frequently cause the flash to overheat and then fail altogether. Although some equipment can handle 50 full-power flashes at 10-second intervals, other units will overheat after 20 shots. Consult the manufacturer about such heavy-duty operation.

Maintaining the Flash Capacitor You recognize the need to remove flash batteries during storage and to charge rechargeable cells periodically, even if not being used. Similar periodic attention must be devoted to maintaining the flash *capacitor* which, if unused for a number of months, loses its ability to hold a charge effectively.

The simple procedure required to bring the capacitor to peak operating efficiency is called **reforming the capacitor.**

1. Set the flash for full-power manual operation.
2. Install batteries known to be in satisfactory condition. (To save battery life or eliminate the need to purchase fresh batteries, an ac

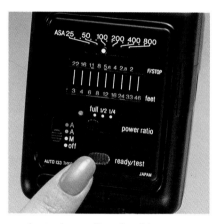

adapter is excellent for this application and so are rechargeable batteries.)
3. Turn the unit on and wait 5 minutes.
4. After 5 minutes, fire the flash six to eight times, waiting between flashes double the time it takes to recycle (as indicated by the ready light).
5. Let the capacitor charge fully before storage.

Reform the capacitor at least every three months to ensure that it will continue to deliver maximum power and minimum recycle time. It might help to jot down some dates on your calendar.

SOME MECHANICAL CONSIDERATIONS

Before any flash can deliver effective performance, you should check on a number of simple, but important, mechanical details. Failure to do so can give disappointing results, to say the least.

Triggering The signal from the camera to fire the flash comes from either a hot shoe or the flash synchronization (sync) outlet found on either the lens barrel or camera body. Most cameras have a shoe that accepts the foot of the flash, but unless shoe and foot have an electrical (hot) contact as shown, the flash will have to be triggered through the electrical cable (called a sync or PC cord) that goes between the camera sync outlet and the flash. (Before buying a hot shoe flash for a cold shoe camera, make sure that the camera accessory shoe does not short out the flash unit.)

Sync Cord If a hot shoe connection is not provided on camera and flash, or for mounting the flash off camera (see pages 46-61), use a sync cord. These somewhat delicate cords—spares are advised—are not generally interchangeable among different brands of electronic flash. Straight or coiled extension cords are available in various lengths.

Synchronization Electronic flash must be synchronized, so that it fires at the instant the camera shutter is fully opened. This is known as *X*-sync. If the camera has an *X-M* switch, set it at *X*. If two outlets exist into which the flash sync cord can be plugged, use the *X* outlet. Many modern cameras have neither switch nor multiple outlets; they are automatically set for *X*-sync. (*M* synchronization is for flashbulbs.) Check your camera instruction manual for flash synchronization information.

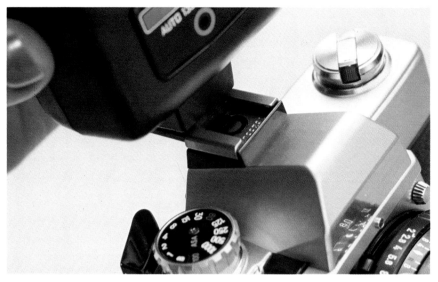

Sliding the flash unit into the hot shoe establishes the electrical connection.

Lacking a hot shoe, look for a connecting outlet for the PC cord on the lens barrel or

on the front or side of the camera.

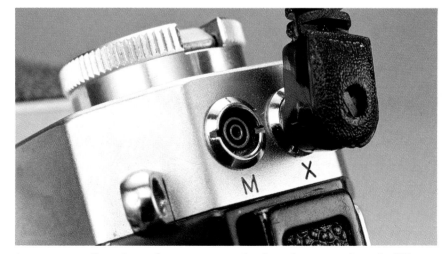

Some cameras offer a choice of synchronization settings—such as "X" and "FP" or "M" for flashbulbs. With a choice of sockets, plug your cord into the "X" socket. With a switch, choose the "X" setting.

Shutter Speed Although the duration of the flash—typically 1/1000-second and shorter—determines actual exposure time for a picture, the **camera shutter speed** must be set to provide a fully open shutter when the flash unit fires. Shutters are located either inside the lens (leaf shutter) or directly in front of the film (focal-plane shutter). Focal-plane shutters require particular shutter speed settings for flash photography.

Focal-plane shutters are commonly found in 35 mm cameras that accept interchangeable lenses. Typical electronic flash synchronization speeds would be 1/60, 1/90, or 1/125 second, but consult your camera manual. Shutter speed dials usually indicate the proper setting for flash. Shutter speeds *slower* than the flash synchronization setting are possible, but ambient light may create ghost images around the subject, especially if the camera is handheld and not perfectly stable or if the subject is moving.

Speeds *faster* than recommended produce a picture that shows only a portion of the frame.

Leaf shutters will synchronize with flash at *any* speed, although 1/500 second is the fastest recommended setting. This flexibility makes balancing flash illumination with ambient light relatively easy. Fill-in flash, which requires such a balancing technique, is discussed on page 74. Again, shutter speeds slower than 1/60 second may not be successful except for special effects.

Compatibility Basically, almost any flash unit will work with almost any camera equipped for electronic flash. It's a question of setting the shutter speed, establishing contact and correct synchronization, and adjusting exposure for the film-speed/flash-power/flash-subject distance variables. Some camera/flash units made by the same manufacturer are even more than compatible—they are designed to work together in a so-called dedicated system. Specially designed circuits in both instruments combine to set automatically correct shutter speed, and flash power for correct exposure and to provide viewfinder signals (such as ready-to-flash signal) when the flash is attached to the camera.

Single-lens reflex 35 mm cameras have a recommended flash synchronization speed— usually 1/60 or 1/125 second. Operation at speeds faster than recommended may give partial images, as seen below. The drawing at left shows how it happens. The sequence at far left illustrates the shutter set at a speed faster than recommended. The two shutter curtains do not expose the entire film frame to the flash burst. At a slower speed (left) the curtains open fully when the flash fires to reveal all of the frame.

1/1000 second

1/500 second

1/250 second

1/125 second

1/60 second

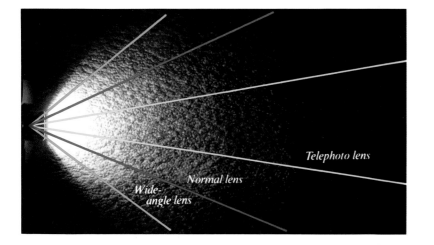

Coverage The light beam from a flash is designed to cover at least the area seen by a normal lens. Some units will cover without additional attachments the area encompassed by a moderately wide-angle lens, such as a 35 mm lens on a 35 mm camera. (Coverage data can be found in the flash instruction manual.) Since a telephoto lens has a narrower field of view than a normal lens, any flash can be used with any telephoto lens.

Many flash units will cover the area seen by a moderately wide-angle lens, such as a 35 mm lens on a 35 mm camera.

Make sure your subject is within the flash range. Further information on the use of flash with wide-angle and telephoto lenses is found on page 42.

You can spotlight the center portion of a scene if you use a wide-angle lens that has wider field of view than your flash unit will cover.

Color Balance Color quality of light from an electronic flash is approximately equal to daylight standards. Electronic flash combined with any daylight-balanced film, such as KODAK EKTACHROME 64, 200, and 400, KODACHROME 25 and 64, and KODACOLOR II and 400, should give excellent results. Flash tubes from different manufacturers, however, do vary a bit in color quality, with a slight bluish cast evident in pictures taken with some flash units. With age, the color quality often warms up a bit. If your flash photographs are consistently too blue, place a warming filter, such as a KODAK WRATTEN Filter No. 81A or Kodak Color Compensating Filter CC10Y, over the flash or camera lens to improve results. Exposure correction is usually not necessary for these light-colored filters.

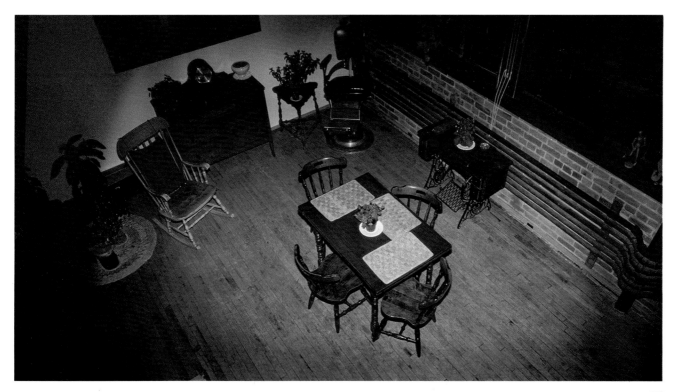

Basic operation

The following chapter provides a step-by-step guide to the operation of automatic and manual flash units. Here you'll find a deeper understanding of how to use your flash unit effectively for the pictures you've been waiting to take. This chapter, incidentally, will be far more valuable if you read it with the instruction manuals for your flash and camera close at hand.

With preliminary concerns out of the way you can begin to photograph. It's important to understand from the beginning that flash techniques and operation may be rather different from conventional photographic procedures.

For instance, subject distance is not a concern when determining exposure for available-light photography. With flash, however, there is both a near and a far limit which determines the distance range for properly exposed pictures.

Also, the range of possible lens apertures is relatively limited with flash. Automatic units may permit only one fixed *f*-stop, although many do allow a 2-, 3-, or even 4-stop range. Manual units restrict lens apertures to one particular value for each flash-to-subject distance (though there are special techniques and equipment to circumvent this restriction).

And finally, variations in shutter speed are usually not an option with flash. With focal-plane shutter cameras, there is one correct speed for proper synchronization (unless very slow shutter speeds are desired for special effects).

AUTOMATIC OPERATION

Automatic flash units contain a sensor that measures the light reflected from the subject and turns the flash off when it determines that sufficient light has reached the film. Although the blast of light appears constant in duration, it actually varies from about 1/1000 second (when small lens apertures are used and/or flash-to-subject distance is great) to as short as 1/30,000 second or less (when large lens apertures are used and/or the flash-to-subject distance is small).

A simple chart can compare the factors which determine correct film exposure to those that govern the operation of an automatic flash unit.

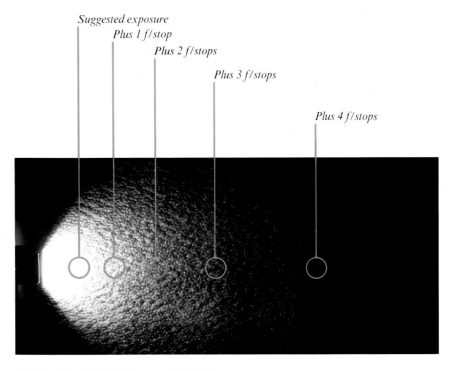

Suggested exposure
Plus 1 f/stop
Plus 2 f/stops
Plus 3 f/stops
Plus 4 f/stops

Flash-to-subject distance is the key factor for exposure with flash photography. As the distance between flash and subject increases, you must increase the exposure by opening up the lens aperture.

The sensor of an automatic flash unit measures the light reflected by a subject and halts light emission when enough light has been reflected for adequate exposure.

Photographic Concern	Operation of Automatic Flash
Film sensitivity	Set film ISO/ASA speed on flash calculator.
Shutter speed	Set camera to correct flash synchronization shutter speed.
Lens aperture	Flash calculator shows correct lens aperture for film speed. If more than one *f*-stop is offered, make choice based on desired depth of field, or on need to conserve batteries (large apertures require less power and allow faster recycling).
Brightness of scene	Determined by power of output of flash. If flash offers multiple-aperture settings, lens-aperture and flash-sensor settings must agree.
Amount of light reaching the lens	Flash sensor must be near lens and facing subject to give correct information about scene illumination.
Measuring exposure	With flash properly programmed for lens aperture and film sensitivity, the auto sensor shuts off flash when it detects sufficient light for correct exposure.

Dedicated Units

While the theory of operation for most dedicated flash equipment is identical to that for sensor automatic flash, many of the steps are unnecessary with dedicated flash. For example, shutter speed is usually set automatically when the flash is attached to the camera. Additionally, when the film speed has been set on the camera, it need not be set on the flash. Also, when the flash exposure sensor is located behind the lens, there's no need for concern about the position of an external flash sensor.

In all other aspects, dedicated units should be handled like their sensor-automated counterparts.

Minimum/Maximum Range

For every flash used in its automated mode, there is a minimum and maximum allowable flash-to-subject distance which will cause over- or underexposed pictures, respectively, if violated.

Those limits are fixed for a particular lens-aperture/film-ISO/ASA-speed combination. If the flash has provisions for a choice of apertures with a particular film, be aware that the near/far limits will change for each aperture. Some flash calculators just show the far limit, others show both near and far boundaries. Consult the instruction manual.

STEP-BY-STEP AUTOMATIC OPERATION

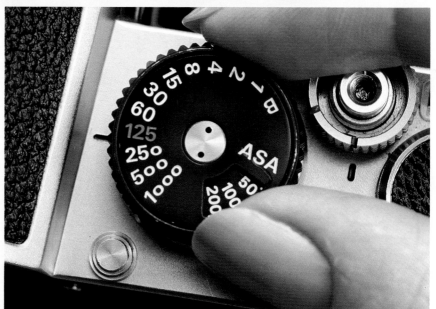

*1. **Above:** set the recommended flash shutter speed.*

*2. **Left:** set the film speed on the flash calculator.*

*3. **Below:** keeping in mind the distance range you'll need, choose the appropriate automatic mode indicated by the flash calculator.*

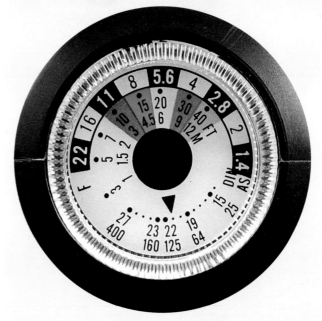

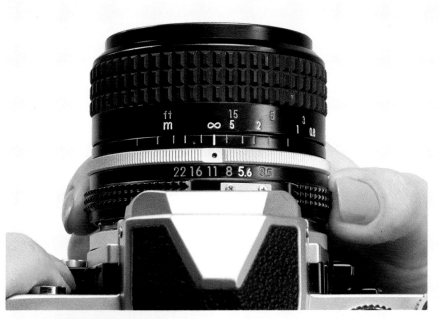

4. Above: *set the flash mode on the flash unit.*

5. Above right: *set the aperture recommended for that flash mode.*

6. Left: *focus on your subject and make sure that it falls within the distance range.*

7. Below: *turn on the flash unit.*

8. Below: *take a picture.*

USE VIVITAR SB-4 POWER SUPPLY ONLY
Photoflash Equipment

LOCK ▶

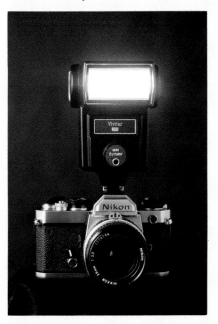

Left: *sensor-automatic flash allows greater freedom and requires less accurate calculation for bounce flash.*

Right: *the short flash duration of an automatic flash with large apertures and close subject gives action-stopping capability.*

Bottom: *the exposure accuracy of a dedicated automatic flash system allows you to record close-up subjects within the distance range without additional compensation.*

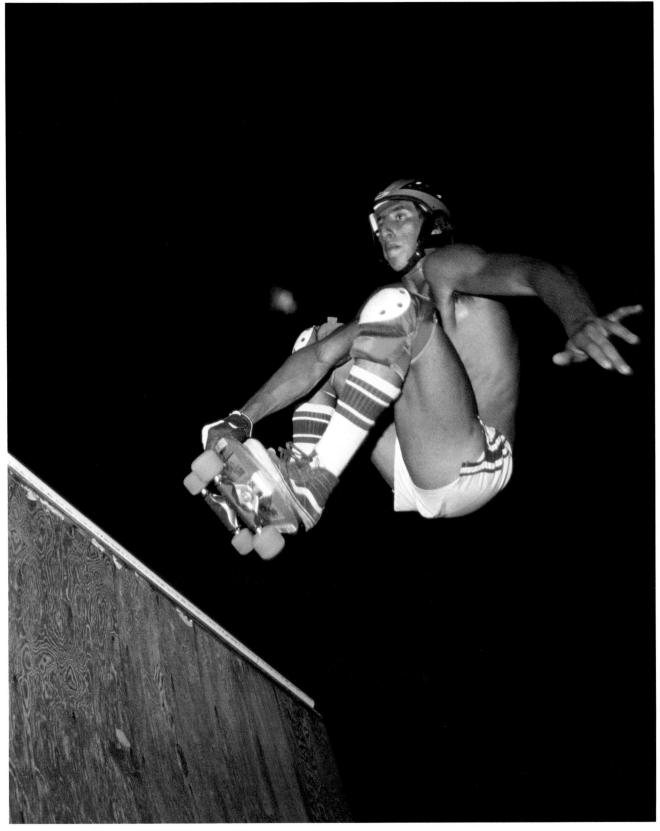

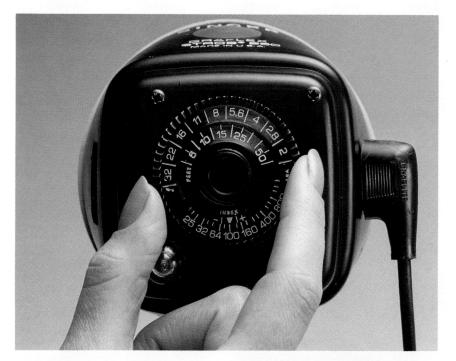

USING THE FLASH CALCULATOR

1. If the flash unit is automatic, set the sensor adjustment to manual (usually marked M).

2. Set the recommended shutter speed.

3. If necessary, plug the flash cord into the X plug on the camera. On older cameras, you may have to set a shutter synchronization adjustment. Consult your camera manual.

4. Adjust the calculator for film ISO/ASA speed.

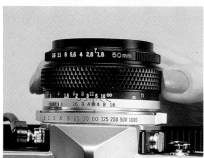

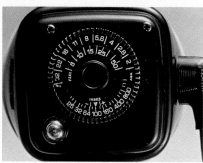

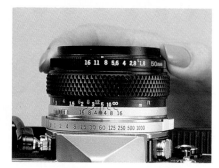

5. Determine flash-to-subject distance. (With the flash mounted on camera, or even off to one side, flash-to-subject distance is the same as lens-to-subject distance. Then focus the camera and read the distance from the lens barrel.)

6. Consult the calculator — the correct *f*-stop can be found opposite the flash-to-subject distance. (Don't confuse the feet and metres scales, and disregard all other numbers that pertain to automatic operation.)

7. Set your lens to the aperture indicated by the calculator. Turn on the flash, and you're ready to photograph.

MANUAL

Some high-power, professional-level flash systems are not equipped for automatic operation. And the same applies to older units, and some inexpensive models. There are also some situations—bounce flash, fill-in, or multiple flash (see pages 49-54, 77-80 and 70, respectively), or the need to override the sensor—when it is better to use an automatic flash in its man-ual mode. In these cases, exposure must be determined and set manually. The procedure differs significantly from automatic-mode operation but is easy to learn and apply. It's certainly not new. From 1929, when Johannes Ostermeier produced the first commercially successful flash bulb in Germany, until the 1970s when automatic electronic flash units took the market by storm, the only quick way to calculate flash exposure was by the method referred to today—with a somewhat superior air—as manual.

Earlier we noted that exposure is determined by the duration of the actual burst of light, which is controlled by automatic flash sensors. The duration is governed by the

flash-to-subject distance (and somewhat by the tone of the subject, see page 40), since light intensity drops rapidly as it spreads out along its path to and from the subject. With near subjects, the flash duration is brief; with distant subjects, duration is greater. But once sensor and lens are set, all pictures within a certain range—say 5 to 40 feet—are taken at the same aperture.

In the manual mode, each time the flash is fired, it emits the maximum amount of light of which it is capable, and for a fixed duration, typically 1/1000 second. Since the amount of light is constant, if one lens aperture were used, nearby objects would be overexposed by the relatively close flash distance while distant objects would be underexposed by the greater distance. For correct exposure, therefore, *the lens aperture must be adjusted for each flash-to-subject distance.*

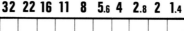

	32	22	16	11	8	5.6	4	2.8	2	1.4
25	5″	7″	9″	14″	18″	27″	3′	4′6″	6′3″	9′
50	9″	14″	18″	27″	3′	4′6″	6′3″	9″	12′6″	18′
64	12″	17″	24″	33″	4′	5′6″	7′6″	11′6″	15′	23′
100	18″	27″	3′	4′6″	6′3″	9′	12′6″	18′	25′	36′
125	24″	33″	4′	5′6″	7′6″	11′	15′6″	22′	31′	45′
160	30″	3′9″	5′	7′3″	10′	14′	20′	28′	40′	57′
200	3′	4′6″	6′3″	9′	12′6″	18′	25′	36′	50′	70′
400	6′3″	9′	12′6″	18′	25′	36′	50′	70′	100′	145′

	32	22	16	11	8	5.6	4	2.8	2	1.4
15	0.13	0.19	0.25	0.37	0.5	0.75	1.0	1.5	2.0	3.0
18	0.25	0.37	0.5	0.75	1.0	1.5	2.0	3.0	4.0	6.0
19	0.33	0.48	0.65	0.95	1.3	1.9	2.6	3.8	5.2	7.5
21	0.5	0.75	1.0	1.5	2.0	3.0	4.0	6.0	8.0	12.0
22	0.65	0.95	1.25	1.85	2.5	3.6	5.0	7.3	10.0	14.5
23	0.8	1.2	1.6	2.4	3.3	4.7	6.5	9.4	13.0	19.0
24	1.0	1.5	2.0	3.0	4.0	6.0	8.0	12.0	16.0	24.0
27	2.0	3.0	4.0	6.0	8.0	12.0	16.0	24.0	32.0	48.0

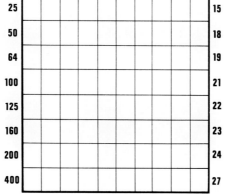

	32	22	16	11	8	5.6	4	2.8	2	1.4	
25											15
50											18
64											19
100											21
125											22
160											23
200											24
400											27

IF FLASH HAS NO CALCULATOR

1. Consult the instruction manual for that particular flash. Look up the **guide number** recommended for the film ISO/ASA speed you're using. If the manual gives a guide number for only one film speed, see page 38 for a formula to determine the guide number for other film speeds.

2. Divide that guide number by your **flash-to-subject distance** (feet for feet, metres for metres); the quotient will be the correct *f*-number to set on the lens. Always use the same units—feet or metres—for your calculations. A metric guide number will not work

for distances in feet.

3. Repeat the preceding step for other distances and make a table of distance/aperture combinations. Tape it to the back of camera or flash. The table will, in general, be valid only for *that* flash and *that* film speed.

4. If using films with different speeds, divide the appropriate guide number to generate other rows of apertures for your homemade table.

5. Now proceed identically as in steps **1**, **3**, **4** and **5** on the opposite page "Using the Flash Calculator."

The two charts at top show how to correlate f-numbers for different film speeds for a hypothetical flash unit and arrive at the flash-to-subject distance. The chart at top left gives the information in feet; the chart at top right gives information in metres. Copy the blank chart for use with your own flash unit.

Though it does take a little work, once you have made the table, calculations will never again be necessary. Obtaining the correct *f*-stop is then only a matter of determining (by focusing) the flash-to-subject distance.

As is probably apparent now, the table that you make provides the same information found on a flash calculator. Both are based on the guide number system.

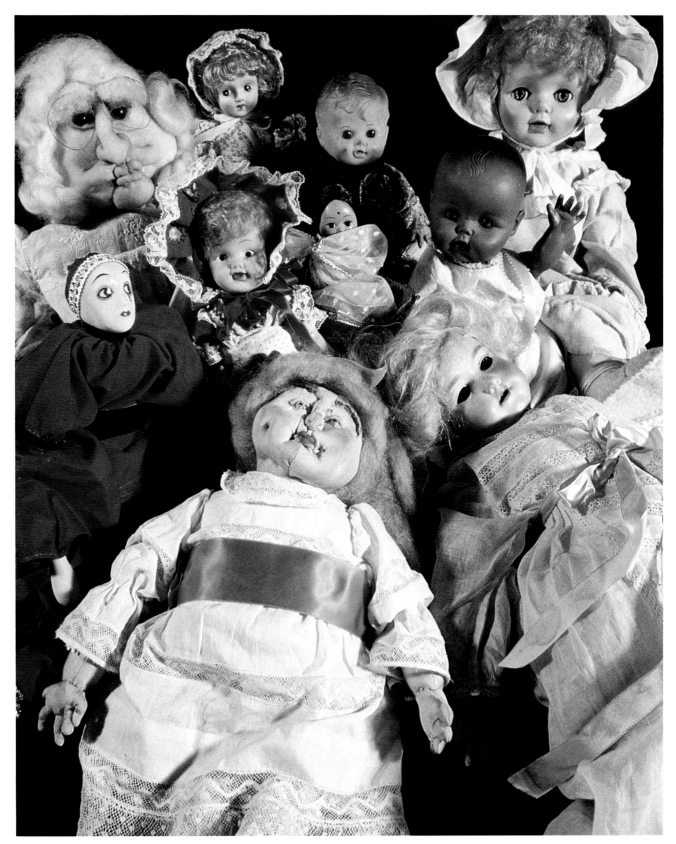

Left: *manual flash units are practical for multiple flash photography because their power output is consistent. The doll collection at left was captured with the light from two flash units. The closer main light was at right and above, and the flash that filled in the shadows created by the main light was located at a greater distance on the left.*

A powerful manual flash unit will give enough light for ceiling bounce with widespread subjects.

The calculated exposure for this wide-angle view called for more light than the flash unit with a diffuser could provide. The photographer gave an extra stop of exposure by flashing the manual unit twice.

READY LIGHT

All electronic flash units have a ready light (usually red or orange) that glows to indicate when the capacitor has charged sufficiently to fire again and produce a satisfactory exposure. It will be only satisfactory because the ready light on most consumer flash units glows when the capacitor is 70 to 85% charged. Full, 100% charge takes about 50% longer. On some equipment the ready light will eventually blink to signal 100% charge.

In the automatic mode, firing the flash when it is only 75% charged produces properly exposed film, unless, due to distance and/or lens aperture, maximum power is called for. In that case, photographs will be a ½ stop, or more, underexposed.

Manual flash exposure, however, relies on 100% power for every shot. Therefore, in the manual mode, failure to wait for 100% charge results in consistently underexposed film.

Most professional flash units have ready lights which do indicate 100% charge as soon as they glow. With all equipment, though, consult the instruction manual.

Most electronic flash units have a small orange light that glows when the unit has recycled and is ready for the next shot. Usually this light indicates partial recycling—perhaps a 75% charge. It's wise to wait a few extra seconds for full power. Some units have a ready light that blinks when the capacitor has stored full power. The bottom picture at right demonstrates the underexposed results from incomplete recycling with a manual flash unit. The comparison photo in the center shows correct exposure at full power.

If discharged prematurely, an automatic flash unit will give enough light, provided that the subject is closer than the maximum distance range for the mode set.

THE IMPORTANCE OF TESTS

We strongly advise that you test and operate new flash equipment with film in the camera and in typical shooting situations before you rely upon it for important work. During such testing you can become more familiar and dexterous with mechanical procedures.

An equally important reason for the serious photographer to test new equipment is to make sure that film is receiving what *you* consider proper exposure. You may have strong feelings about how much exposure is needed for the images you shoot. Without flash, you meter light on the scene, make any necessary compensation, adjust your camera, and shoot. Testing the output of your flash gives you the same confidence in your flash exposure as familiarity with your camera meter gives you for natural-light exposure.

Automatic sensors are designed to cut off the flash when film has been exposed according to the flash manufacturer's standards. *Does the manufacturer test on negative or slide film? If slide film, on what projector or light box are transparencies viewed, and at what magnification? If negative film, do their ideas of shadow detail coincide with yours?*

Similarly, the flash manufacturer's published guide numbers, which are also used to provide the suggested lens aperture on the exposure calculation of the flash unit, are just that—guides and suggestions! They are based on so-called average conditions: small-to-medium-size rooms with white ceilings and light-colored walls, and medium-tone subjects. Such situations do exist certainly, but not always.

CONDUCTING THE TEST

1. For testing, use the same film that will be used for most of your later flash photography.
2. Make certain that all camera and flash controls (shutter speed, lens aperture, flash sensor, film ISO/ASA speed) are properly set.

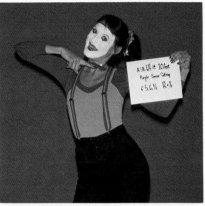

Recommended plus ½ stop

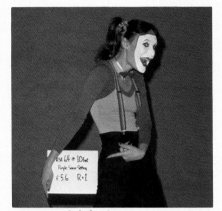

Recommended plus 1 stop

Recommended

3. As a starting point, expose according to the manufacturer's recommendations. Instead of taking notes, put a card in the scene indicating:
 a. film ISO/ASA speed,
 b. lens aperture,
 c. sensor setting,
 d. flash-to-subject distance (10 feet is handy for calculation), and
 e. any other pertinent information. (In our example, "Mfg" means manufacturer's recommendation, and "Purple" refers to the color-coded sensor setting.)
4. Now, without changing anything but the lens aperture, take the identical picture with the lens open ½ stop larger. ("Mfg + ½" means ½ stop larger aperture than manufacturer's recommendation.)

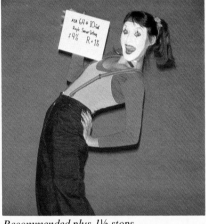

Recommended plus 1½ stops

5. Continue this bracketed series of exposures for 1 full stop larger aperture, then 1½ stops larger, and finally ½ stop smaller. (Seldom is it necessary to go far in the underexposed direction.)
6. Repeat steps **3**, **4**, **5**, above, for other scenes and distances.
7. Process the film in your normal manner, or send it to your usual processing lab. Then, using your standard viewing conditions, select the exposure for each scene that you deem correct.
8. Most people find that it's easier to make critical exposure judgments from slides, but if negative film has been used for the tests, and if you are familiar with evaluation criteria, it is better to select proper exposure from the negatives rather than from the prints. (Negative film has a fairly generous tolerance, or latitude, for overexposure, unlike slide film, which must be accurately exposed.)

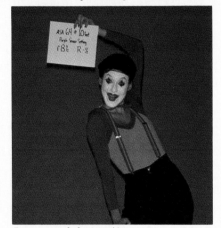

Recommended minus ½ stop

The series above gives an idea of what a flash exposure test should show about the power rating of your flash and how it compares with the typical use you'll give it. In this simulated test, the flash required an extra stop to give normal exposure.

Applying the Results

When evaluating the test film, look for general trends. Do not base conclusions on one scene; it may be an exception, or you may have made a mistake. The questions to ask are, *"Do the manufacturer's recommendations generally provide properly exposed film?"* or *"Are the exposures I prefer generally ½ stop more than those produced by the recommendations?"*

If test results convince you to modify the manufacturer's suggestions, do the following. Instead of using the true film ISO/ASA speed, set the flash calculator dial to a modified film speed number obtained from this chart:

If, compared with manufacturer's recommendations, properly exposed frames have:	Then modify ISO/ASA setting by:
½ stop more exposure	reducing film speed *multiply by 0.8*
1 stop more exposure	reducing film speed *multiply by 0.5*
1½ stops more exposure	reducing film speed *multiply by 0.4*
½ stop less exposure	increasing film speed *multiply by 1.4*

If you are testing the manufacturer's published guide numbers, the chart is also valid. Just use the modified film speed to find a corresponding guide number in the manufacturer's data.

Alternative method: Another solution is to leave the true film ISO/ASA speed on the flash calculator, and modify all lens settings by an amount indicated by your tests. For example, if tests consistently indicated a need for ½ stop more exposure than the flash manufacturer's recommendations produce, and if the flash calculator (or your homemade guide-number chart) shows $f/5.6$ for a particular film, then set the camera lens halfway between $f/5.6$ and $f/4$.

Guide Number Test

For manually operated flash, where a published guide number is unavailable and the equipment does not have a flash calculator, you can test to determine a guide number.

1. At exactly 10 feet from the flash, place an average, medium-toned subject in a room that approximates your average shooting conditions.

2. Make a series of exposures in ½-stop increments from $f/2.8$ to $f/16$ (or even to $f/22$ if you are using a very powerful flash with high-speed film).

3. From the processed film select the exposure that you feel is correct.

4. Multiply the f-stop used for the best exposure by 10—the product is your guide number in feet for the particular film you are using. See the table for accurate ½-stop values.

full stops	1.0	1.4	2.0	2.8	4.0	5.7	8.0	11.3	16.0	22.6
½ stops		1.2	1.7	2.4	3.4	4.8	6.7	9.5	13.5	19.0

As explained earlier (see page 33), you can find the correct lens aperture for *any* flash-to-subject distance by dividing the guide number by the flash-to-subject distance. It is still advisable to further test such a guide number—in fact, it's even advisable to test a manufacturer's suggested guide number—under a range of actual photographic conditions and distances before trusting it for critical photography (see page 37).

Once a guide number (call it GN_1) has been found for a film having a particular speed (call it film speed$_1$), the guide number (GN_2) for a film having different speed (film speed$_2$) can be calculated from the formula:

$$GN_2 = GN_1 \left(\sqrt{\frac{\text{film speed}_2}{\text{film speed}_1}} \right)$$

For instance, you're using a flash that has a guide number of 40 with ISO/ASA 25 speed film. For a film with an ISO/ASA speed of 100, you do the following:

$$GN_2 = 40 \left(\sqrt{\frac{100}{25}} \right)$$
$$= 40 \left(\sqrt{4} \right) = 40 \, (2) = \textbf{80}$$

The guide number for the ISO/ASA 100 speed film is 80.

DIFFICULT SITUATIONS

Sensors and guide numbers produce excellent flash exposures in most cases. But just as in-camera or hand-held exposure meters can be fooled by circumstances such as backlighting or unusually light or dark subjects, there are fairly common situations in flash photography that may lead to poorly exposed or poorly lighted flash pictures.

Aiming a flash unit at a reflective surface will give an unattractive result with any flash unit. An automatic flash unit will sense the reflected light and cut off early giving underexposure. Avoid reflections.

Automatic Flash Considerations

Automatic flash sensors read the light coming back from the scene and govern the flash output so as to produce properly exposed medium tones. If the majority (of the area) of the scene is medium-toned, or if the average of the scene's components is equivalent to a medium tone, automatic exposure will be correct.

It is obvious now, that with the flash's single, blind desire to make everything a medium tone, it will produce unacceptable exposures when it encounters subjects you do *not* want to come out medium-toned.

Similarly, the flash sensor is not smart enough to expose properly an object that takes up only a small portion of the field of view. It doesn't know what is an important subject and what is distant background.

Correct automatic exposure in these special situations can be achieved by first realizing that the scene can fool the sensor. Next, decide whether, without compensation, the picture would be too light or too dark. Then close or open, respectively, the camera lens instead of

Faced with the light-toned scene above, an automatic flash sensor cut the power prematurely which underexposed the subject. It's wise to bracket exposures, especially with slide film, but you can usually allow at least an extra ½ stop of exposure. A manual flash unit will be unaffected by subject brightness.

using the exact aperture suggested by the flash. Seldom is compensation by more than 1 or 1½ stops required; bracket exposures if in doubt.

Experience gained through trial and error, and careful analysis of results—enhanced by notes detailing those trials—will be the best way to learn how much to override the automatic sensor.

Extremely dark subjects will not reflect much light from a flash. The sensor of an automatic flash unit will permit overexposure unless you cut back. Again, bracket with slide film. Start by decreasing exposure at least a ½ stop.

The power of a manual flash unit is determined with a set of average conditions—usually a small room with light-toned walls and ceiling. Outdoors at night or indoors in a large area, there are no extra surfaces to reflect the flash back at the subject. Basing your exposure solely on the flash calculator will very likely give underexposure. Allow ½ to 1 stop extra exposure with such subjects.

Manual Flash Considerations

Exposure in the manual mode is based on a particular guide number, which, as stated earlier (see page 33), is only a guide. In general, it usually assumes a room with a white ceiling 8 to 9 feet high and possibly one or more light-colored walls reasonably near the subject. Walls and ceilings pick up light spilled past the subject and reflect it back to enhance the overall level of illumination.

Photographing under significantly different circumstances, such as outdoors or in a large arena, will usually require ½ to 1 full stop or more additional compensation.

And, subjects that are unusually dark or unusually light usually require ½ to 1 full stop more, or less, respectively, than indicated by straight guide number calculations.

FLASH WITH OTHER LENSES

As noted earlier, the beam spread of a standard flash is designed to cover the area encompassed by a camera's normal lens (see page 25). Some flash equipment will cover a slightly wide-angle optic, such as a 35 mm lens on a 35 mm camera, or a 60 mm lens on a 2¼ x 2¼ format camera, but do check your flash instruction manual before attempting wide-angle flash photography.

The photos at right illustrate the covering power of an electronic flash unit with a zoom flash head. At top you see the normal lens setting of the zoom head. The center illustration shows the wider and shorter pattern thrown by the wide-angle setting. The bottom view shows the long, narrow coverage of the telephoto setting.

Flash with Wide-Angle Lenses

An excellent flash technique for illuminating the broad area seen by a wide-angle lens is bounce flash, which is discussed on pages 49-54. Here, however, we concentrate on methods which spread the direct flash beam. These techniques are effective for wide-angle lenses with focal lengths as short as 24 mm when used on a 35 mm camera, or 40 mm for 2¼ x 2¼ cameras.

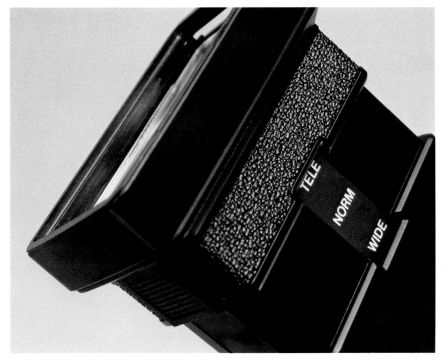

1. Accessory frosted plastic diffusers (above) which attach to the front of a flash are available in various densities, depending on beam spread required. No exposure compensation is necessary when using automatic flash. However, both the minimum and maximum points of an automatic range *decrease* by 25 to 50%. Consult the instructions that come with the diffuser. In manual mode, the guide number *decreases*. Here, too, check the instructions.*

2. Similar in function to the diffuser at left, transparent plastic Fresnel lenses, offered as accessories by the flash manufacturer, also attach to the flash head. Tiny grooves cut in the plastic disperse the light beam but with less loss of intensity than occurs with diffusers. Additionally, Fresnel lenses come in specific designs to match the field of view of specific camera lenses. They require exposure considerations similar to those noted for diffusers.*

3. Zoom flash units (above) are constructed with a Fresnel lens mated to a housing which slides in and out over the flash head. This configuration is able to change the beam spread, usually from moderately wide-angle, through normal, to moderately telephoto. Since they are an integral part of the equipment, zoom heads are more convenient than individual Fresnel lenses, though they often do not cover as extreme a range as the latter. Again, maximum and minimum ranges in the automatic mode decrease at the wide-angle setting, as does the guide number for manual operation.*

The sensor of an automatic flash, except those dedicated systems where the sensor is mounted behind the lens, may not see the scene the same as the lens and flash. Some compensation may be necessary for extreme or unusual situations.

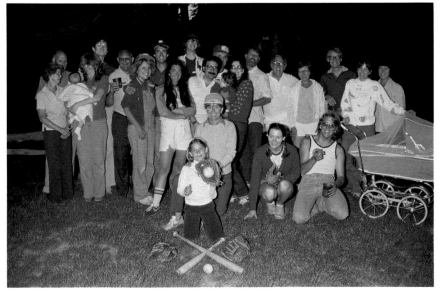

To provide even illumination for this large, widespread group of merrymakers the photographer used a wide-angle Fresnel lens fitted over the flash head.

Flash with Telephoto Lenses

With flash heads designed to cover a field seen by normal focal length camera lenses, there is more than enough light coverage of the scene for telephoto lenses. No changes in exposure procedures are required for either automatic or manual mode.

But why waste valuable light on parts of the scene not even noticed by the camera lens? By concentrating the flash output into a narrow beam that duplicates the angle of view of a telephoto lens, this wasted illumination can help to increase the distance range of the flash and/or decrease the size of the aperture for greater depth of field and/or conserve battery energy.

Few birds would permit photography at this close range. The photographer used a flash with a zoom head to match the light pattern to the coverage of the telephoto lens.

Note: Just as a spotlight effect is created when wide-angle camera lenses are used with normal flash heads (see page 25), a similar effect may be realized by using a normal camera lens and a flash fitted with a telephoto attachment.

1. Inexpensive clip-on Fresnel lenses (above) are available to concentrate the flash beam. They are identical in style to those mentioned before for wide-angle beam spread. Specific Fresnel lenses are made to match the angle of view of most telephoto lenses up to about 200 mm for a 35 mm camera (or equivalent for other camera formats). Note that you can always use a camera lens that has a focal length equal to or longer than the focal length meant to be covered by the Fresnel lens.

When telephoto Fresnel lenses are employed with automatic flash units, both near and far automatic-range limits increase considerably. It then becomes very easy to overexpose subjects by inadvertently working too close. In manual mode, guide numbers also increase considerably—a definite advantage for sports or distant nature photography. Consult the instructions for the Fresnel lens to find corrected values for automatic ranges and for guide numbers.

2. The same zoom flash units mentioned earlier for wide-angle lenses also have settings which cause the beam angle to coincide with that of moderate telephoto lenses. Automatic ranges and guide numbers are increased in a similar manner as with the Fresnel lenses noted directly above.

3. Some professional flash equipment has removable reflectors which may be interchanged behind the flash tube. If available, a deep, polished parabolic bowl provides the required concentrated beam of light for telephotography.

You've already guessed that this picture was made from terra firma rather than the chilly water of the pool. With a telephoto attachment for the flash unit, the photographer was able to supply enough light to catch this swimmer close-up with a telephoto lens.

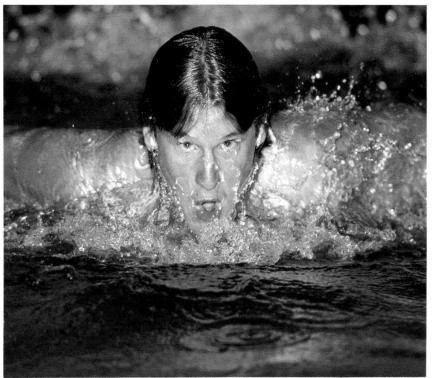

Basic off-camera operation

Removing your flash unit from its customary direct camera connection offers myriad possibilities for pleasing effects. On-camera flash provides a flat illumination that can be rather harsh. When your flash is off the camera, you can create illumination that gives shadows for form or that is reflected for a softer quality.

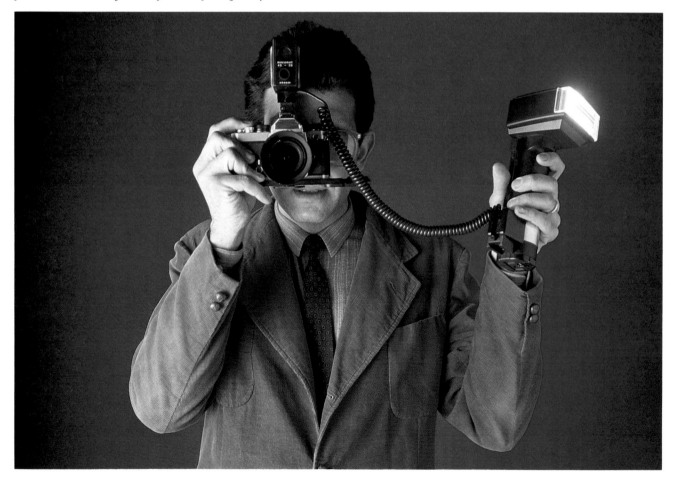

OFF-CAMERA FLASH

While on-camera flash is fast and convenient, considerable improvement in modeling—subject shape, texture, and general appearance created by the light—frequently occurs when you position the flash away from the camera. The goal is to have the light falling on the subject more from the side, top, or even bottom than directly from the front.

Flash on-camera tends to give flat lighting with no relief for the form of the subject. Placing the flash off to one side and somewhat higher than the camera gives interesting shadows that develop a three-dimensional appearance.

EXPOSURE CONSIDERATIONS

Manual Operation
Because the guide-number system is based on flash-to-subject distance, you need only determine that distance and then select the lens aperture indicated (see page 33).

Automatic Units
In most situations, an automatic flash placed away from the camera, and aimed directly at the subject, can be operated in the same manner as if it were on the camera. However, make certain that the flash sensor is accurately aimed at the subject, and the flash-to-subject distance is within the allowable automatic range.

Note that the area covered by a particular flash, or a flash equipped with an auxiliary-beam director lens (see pages 42-45), assumes that the flash is mounted on or very near the camera. If the off-camera *flash*-to-subject distance is less than the *camera*-to-subject distance, the field seen by the camera lens will not be completely illuminated. (This may be used to creative advantage.)

A second method of automatic exposure is available if the flash has provisions for remote sensor. The sensor is placed on the camera, but connected via a special extension cord to the off-camera flash. Regardless of the flash position, the sensor will read the light getting to the lens. Here, too, don't place the flash outside the manufacturer's recommended flash-to-subject range.

There are two main advantages to the remote sensor. First, aiming of the flash is not as critical, and second, if the flash is placed to the side of the subject, or overhead, the sensor at the camera will not be influenced by the background or subject that doesn't appear in the picture.

Dedicated Units
If the flash sensor is inside the camera, the flash may be placed anywhere. However, a special extension cord for *your* dedicated flash/camera combination must be used, and the flash cannot be placed outside the manufacturer's recommended flash-to-subject range.

If the sensor is on the flash, the same special extension cord will be required, but follow the procedure for regular automatic units.

When removing your automatic flash from the camera, make sure that the sensor can see the same subject that the camera lens sees. With a flash-mounted sensor, the angle between flash and camera should not be too great or the sensor will see a different scene from the film. A remote sensor attached to the camera will give a relatively true reading as will the film-plane-mounted sensor of a dedicated system.

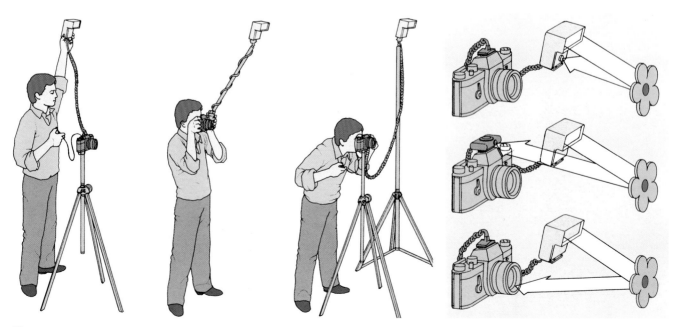

BOUNCE FLASH

Small light sources produce hard shadows, locally flat lighting, and illumination that rapidly falls off in intensity with distance. And for all but tiny close-up subjects, a flash head can be considered a small source.

Off-camera direct flash mitigates some of the unfavorable qualities of direct, on-camera flash, but direct light from a small source, on or off the camera, is still harsh. It cannot be used to illuminate a scene evenly with substantial front-to-back depth, and it never looks like natural light—it always looks like flash.

For every difficulty, there is usually a solution. If the flash is aimed not at the subject but at a large surface such as a wall, ceiling, or cardboard reflector, that large surface now becomes the source. The scene is then bathed with soft, broad illumination that falls on subjects and shadows from many directions. And because it comes from the side or top, and not directly from in front, shapes and textures are nicely defined.

Furthermore, light bounced off a ceiling simulates the indoor overhead illumination with which we are so familiar. Similarly, light bounced off a wall falls on the subject in the same beautiful manner as soft, indirect light from a window. Bounce flash photography looks more believable.

Bouncing your flash off the ceiling or a nearby wall will help to spread out the light to cover a large area as you see at right. Because the bounce surface becomes a large source of illumination, the light for the photo above was much more gentle than direct flash would have been.

Positioning the Flash

The method used to position the flash for bouncing depends on your flash model and how it is normally attached to or next to the camera. One or all of the following techniques will work with any flash:

1. Once the camera is focused, hold it with your right hand, while the left hand holds and aims the flash. One-hand camera support is not detrimental to image sharpness—the short flash duration freezes all but radical camera movement unless the exposure for ambient light is close to that for flash exposure. With a slow shutter speed in this situation, you may get ghost images.

2. Mount camera and flash on one of the commercially available flash grips that allows quick disconnect of camera and flash. The two are united for carrying, focusing, and composing; for bouncing, the grip (in the left hand) is separated from the camera platform (in the right hand) and aimed at the bounce surface.

3. Flash units with tilting bounce heads should be positioned as required (see "Aiming the Flash," on page 52) while attached in the normal manner.

Many bounce heads, however, tilt only on one axis, prohibiting ceiling bounce when the camera is held vertically, or wall bounce with

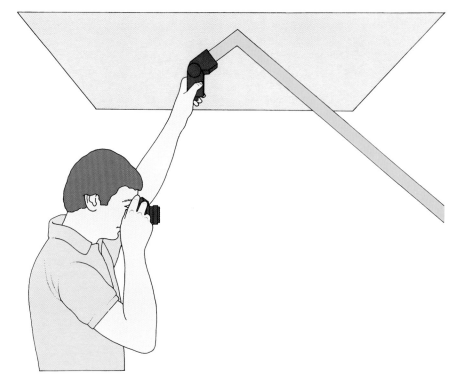

horizontal compositions. In these cases, handhold the flash as noted in 1 above, or use a grip with a tilting flash shoe.

4. Insert a flash swivel below the flash. Though a bit slow to operate, these swivels work. Make certain the mechanical connections are secure.

Flash units that have tilting heads are ideal for on-camera operation. All you have to do is tilt the flash head at an angle that will reflect light off the bounce surface onto the subject.

The Bounce Surface

Select a bounce surface appropriate for the subject. If the flash is too close to the reflector, the light will not have sufficient distance to spread out and become a large source. Conversely, if too far, the light may spread out more than the subject requires, wasting illumination.

Ceilings are traditional bounce surfaces, but don't hesitate to use walls, a shade or blinds pulled down over a window, or even a cardboard reflector or an overcoat. In all cases, the bounce surface must be light in tone, and, for proper color rendition, the surface should be white, slightly off-white, or gray. Unusual color effects result from bouncing off a colored surface.

For normal color rendition of your subject, use a neutral colored bounce surface. Don't hesitate to bounce your flash off extravagant colors for special effects. Light-toned surfaces, incidentally, will reflect more light than dark surfaces.

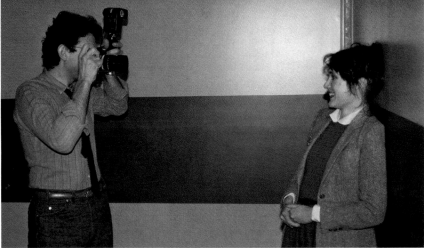

Aiming the Flash

The flash head must be angled so that light reflected from the bounce surface will fall where you want it. As the diagram shows, this is best accomplished by aiming the flash head at a point midway between flash and subject. Unsuccessful bounce flash pictures can often be traced to careless aiming—the light falls in front of or behind the subject. Particularly with flash mounted on the camera, it is easy to change the aim point of the flash head accidentally as the camera is moved for desired composition. Make sure also that direct flash doesn't accidentally spill onto the subject. Be careful!

Aim your flash carefully so that the beam of reflected light illuminates your subject rather than the background. If your flash unit has a confidence light, you'll know immediately if you've aimed the flash correctly, and if there's enough light for good exposure.

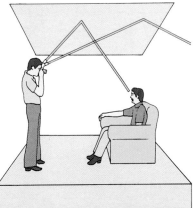

Operating Considerations

The desirable qualities of bounce light are obtained at the cost of:
1. significantly limited range when compared with direct flash,
2. the need to use relatively large apertures, thereby limiting depth of field, and
3. somewhat more complicated exposure considerations.

Bouncing the light weakens its intensity at the subject. The bounce surface, even if white, absorbs some light energy, and, more significantly, scatters the light in directions other than toward the subject.

This diminished brightness dictates larger apertures. And whatever the flash unit's range for direct flash, it will be greatly diminished when used for bounce. This is one case where high-power flash equipment and/or fast film can be extremely helpful.

Note: One helpful technique requires you to tape a piece of white cardboard to the flash head so that a little of the flash reflects a shorter distance. This bit of brighter light can fill in shadows from overhead bounce light and put a little twinkle in your subject's eye.

BOUNCE FLASH EXPOSURE

Automatic Mode

Automatic mode operation is only possible with bounce flash if the flash sensor can, regardless of flash head position, be aimed toward the subject from the camera position. (If it cannot, use the manual mode, described overleaf.) This requires a flash with either a remote sensor, removable from the main unit, which may be placed on the camera or a sensor mounted on the body of the flash which always faces forward, regardless of flash position. Dedicated flash units that rely on a sensor inside the camera fall into the first category. Those with the sensor on the flash may only be used for bounce in their automatic mode if the sensor can be kept aimed at the subject.

Other than the limitations just mentioned, and those on page 40, automatic sensors generally provide correct exposures in bounce applications. However, underexposure does occur frequently, not because of inadequacies in the sensor but because the power required exceeds the capabilities of the flash. The long flash-to-subject distance, plus the absorption and scattering losses from the bounce surface can lead to insufficient illumination if:

1. the flash unit is small,
2. film speed is low (ISO/ASA 25, 64, or even 100),
3. bounce distance is long (12-foot ceilings and/or distant subjects),
4. bounce surface is a poor reflector (non-white), and
5. any combination of these factors.

A confidence light (that shows if there's enough flash light for good exposure) will provide some help here.

It is important to note that the flash manufacturer's suggested near and far limits of automatic operation are specified for direct flash only. Using bounce techniques, both limits decrease by approximately 50%.

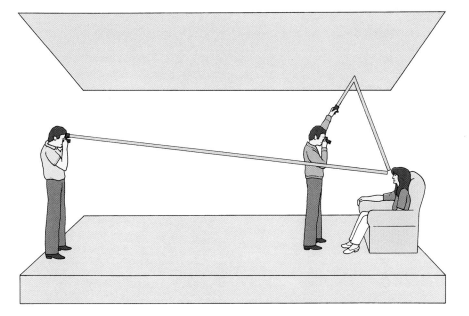

To assure properly exposed bounce flash pictures with an automatic flash, do the following:

1. Sensors having settings for various lens apertures should be set for the largest, or next to largest aperture. When subject, flash, and bounce surface are only a few feet from each other, this is usually not necessary.
2. The total distance from flash to bounce surface to subject should not be more than about 50% of the maximum direct flash distance. (It's wise to practice estimating distances or focusing on the bounce point from the camera and subject positions and adding the total.)
3. If so equipped, check the flash's confidence or sufficient exposure indicator light. If it doesn't glow immediately after firing the flash, move the flash and/or the subject closer to the bounce surface.

Remember that automatic flash operation dictates a lens aperture for a particular film speed. With moderate- and high-speed films, the largest allowable aperture for automatic operation may be $f/4$ or even $f/5.6$. Yet the bounce situation may require $f/2.8$ or $f/2$. Switching to the manual mode, as shown overleaf, permits use of larger apertures and can produce successful results where automatic operation would not.

When light from the flash strikes the bounce surface and spreads out, two phenomena occur that require exposure increase over direct flash. First, the bounce surface absorbs some of the light. Second, because the bounce surface scatters the light into a wider pattern, the intensity of the flash is lowered. Generally, you'll need to photograph from much closer distances than the maximum distance recommended for your flash unit.

Manual Mode

With modification, the guide-number system for flash exposure works quite well for bounce applications:

1. Carefully estimate the distance from the flash to bounce surface to the subject. Then, use this distance to obtain the corresponding lens aperture as you would for direct flash (see pages 32-33).

2. Now open the lens approximately 2 stops more than determined by step 1 above. Non-white reflectors and/or very long (over 30 feet) distances may require 2½ or even 3 stops additional compensation. Very short distances—less than 6 feet—may only need 1 stop compensation. Practice in a variety of situations and circumstances is advised and gives you a better feel for the amount to open the lens.

Note: When flash is used at close distances with high-speed films, the required aperture (manual mode) for direct flash is often smaller than the smallest *f*-stop. Bounce flash can often overcome that problem.

While the exposure techniques explained above do work well, those contemplating frequent and/or critical bounce flash photography are advised to consider a flash meter. (See pages 58 and 72.) The meter accurately measures the actual flash illumination on the subject, regardless of distance or bounce surface characteristics.

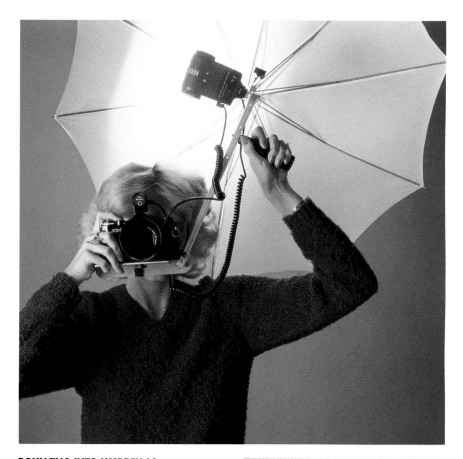

BOUNCING INTO UMBRELLAS

Flash bounced from walls, ceilings, and other flat reflectors is extremely effective for room-size situations, and even portraits and still lifes. However, these bounce surfaces leave much to be desired in the way of directional control. They also waste considerable light energy, and they may have an undesirable color. What's more, light-colored walls and ceilings frequently either do not exist at all or are too far from the subject to be of much use.

A photographic umbrella, used to reflect light from a flash, provides the soft luminosity of a large light source. Umbrella illumination has good directional control, proper color characteristics, and wastes far less light than a flat reflector. An umbrella, stand, and flash also makes a reasonably portable package with sophisticated capabilities.

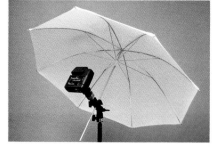

Bouncing your flash into an umbrella is an excellent way to soften the harsh light of direct flash and to control the direction and the intensity of the illumination. There are portable umbrella rigs available, as well as units that will mount on a separate stand.

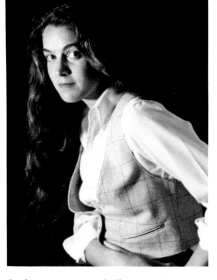

In this comparison of off-camera direct flash **(above)**, ceiling bounce flash **(top right)**, and umbrella-bounced flash, note how the umbrella offers the best features of each of the other methods. The illumination is directional enough to give some form to the model's features, yet maintains some of the soft quality of the ceiling-bounce shot.

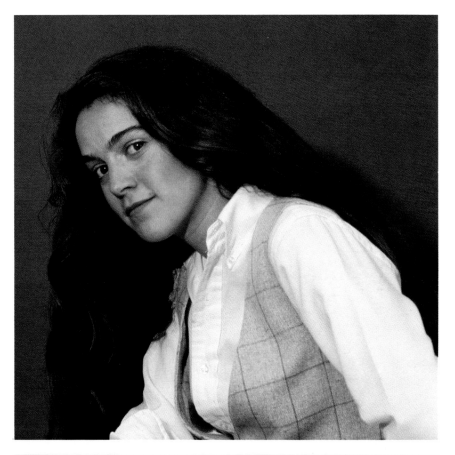

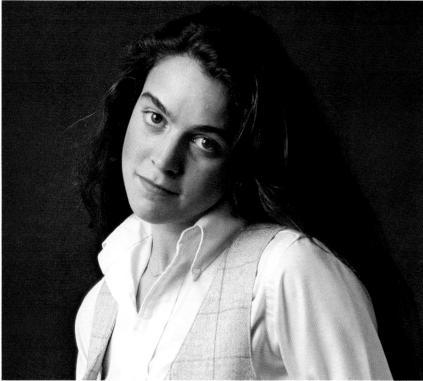

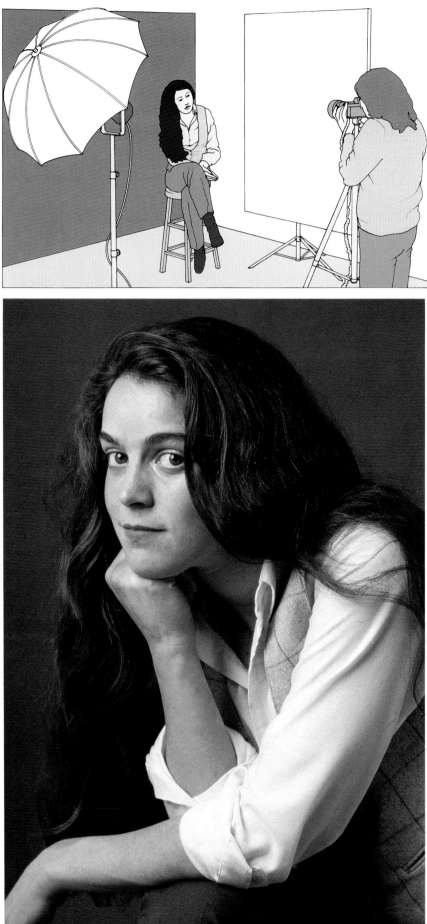

You can add an extra element to any off-camera flash photography by including a simple reflector to brighten shadows. The reflected light will always be less intense than the main light.

Exposure with Umbrellas

Because the flash is mounted completely away from the camera, automatic exposure operation is only possible if the flash unit has a remote sensor (see page 48).

In manual mode, the modified guide-number system described for bounce flash from flat surfaces, (page 54), can be used, though exposure compensation can vary from 1 to 2 stops, depending on umbrella material. Of course the flash-to-subject distance is the sum of the flash-to-umbrella plus umbrella-to-subject distances.

Exposure with umbrellas may also be determined from photographic tests. Make a series of pictures of an average subject with the umbrella at various distances, say 2.8, 4, 5.6, 8, and 11 feet. (These numbers look suspiciously like *f*-stops. The result is similar. You get ½ as much light at 11 feet as you do at 8 feet. This relationship makes future calculations easier.) For each distance bracket your exposures. After processing, choose the correct exposures and, in general, use them for all photography with the umbrella at the corresponding distances. You will find that umbrella placement is not very critical to correct exposure, which gives you the freedom to angle it differently with respect to the subject and to make small changes in umbrella-to-subject distance without worrying about exposure alterations.

BARE-TUBE FLASH

A number of professional electronic flash units have provisions for photographing with a bare flash tube. Because there is no reflector behind, nor lens in front of the tube, light is emitted in all directions.

When used in a small-to-moderate-size room, the subject receives both direct light from the tube and fill-in bounce illumination reflected back from the walls, ceiling, and floor. Lighting quality falls between hard, direct flash and soft, but directional, bounce flash.

Bare flash tubes are generally available only on manually operated equipment, so exposure calculations must be via the guide-number system. (See page 33.) Reliable guide numbers are usually provided by the manufacturer, and they are based on the fact that the *direct* light to the subject determines the actual exposure. Stray, bounced light fills in harsh shadows and provides ambient illumination around the subject, but usually does not contribute noticeably to the light intensity on the subject.

Bare-tube flash light reflects off all the surfaces in a scene so that the subject receives illumination from all directions as well as from the flash itself. This method provides even lighting as well as some shadow for modeling.

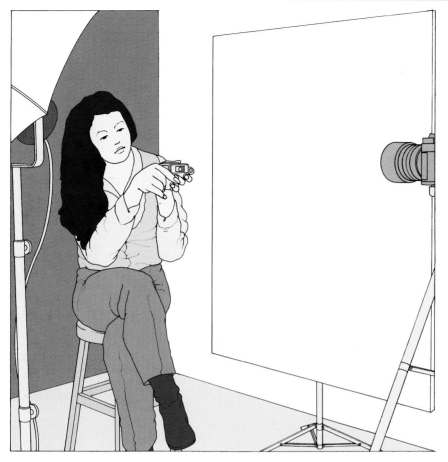

FLASH METERS

Exposure determined by automatic sensor or the guide-number system is generally quite satisfactory for either direct or simple bounce-flash photography. With more elaborate flash setups, correct exposure and proper lighting ratios are often difficult to determine without time-consuming calculations or tests.

The flash meter is a useful instrument capable of solving these problems. Generally placed at the subject for an incident light reading, the meter may measure both the flash and natural ambient light. Readout is an *f*-stop or a numerical value to match with an *f*-stop on the meter's scale. The sensitivity range is usually far greater than the automatic sensor of a typical flash unit.

Of course, the flash unit(s) must be fired to obtain a reading, though with modern flash meters there is no need to connect the flash to the meter by wire. Just turn on the meter, then fire the flash. (Many professional-level flash meters permit the meter to trigger the flash through a cable.)

It is advisable to test a flash meter under a variety of conditions before trusting it for important projects. Make flash pictures near and far, direct and bounce, and with both weak and strong ambient light. Take careful notes, use aperture cards, bracket exposures, and compare your results with the meter's recommendations. (See page 72.)

Held at the subject position during a test flash, a flash meter will register a value in LED's as you see below or on a dial that you translate on the meter scale into an aperture setting. Some sophisticated flash meters give the aperture directly.

DIFFUSION

At the beginning of the "Bounce Flash" chapter, we indicated that the harshness of direct flash is due to the small size of the light source. Bouncing light from a small source onto a broad surface turns that surface into a larger source, softening the illumination.

A second method of softening the light involves placing a large translucent diffuser in front of the flash. Flash output strikes the diffusing surface, causing it to glow uniformly and brightly. This now-broad source illuminates the subject more evenly, filling in shadows and softening transitions between foreground and background.

Compared with bounce techniques, diffused flash illumination is considerably brighter (there is less wasted spill) and directionally more controllable. Diffused illumination is not as good as bounce for lighting an entire room, but is frequently superior for portraits and still lifes, and for photographing industrial or commercial products and medical specimens.

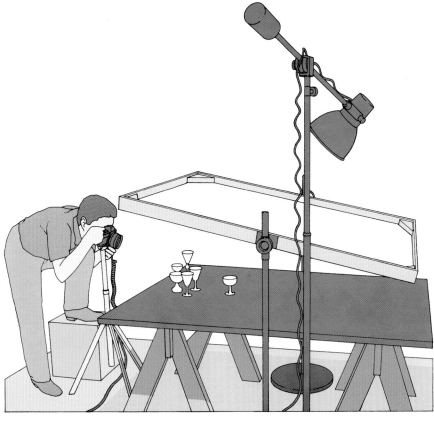

Positioning a large sheet of diffusing material in front of your flash helps to spread out the light as though from a large light source instead of the small flash head. Diffusion helps to lower contrast and decrease reflections from smooth surfaces as you see in the bottom photo of the comparison below.

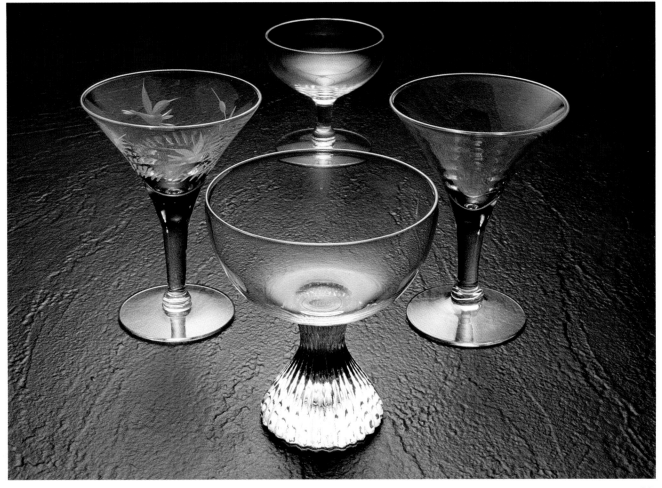

Diffusers

Flash manufacturers offer plastic diffusers that slip onto the flash head, and which are fine for wide-angle photography (see page 43). However, being nominally the same size as the flash head, they cannot soften the light nearly as much as would a large diffuser.

Left: an inflatable diffuser that attaches to the flash head.

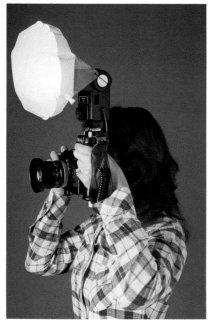

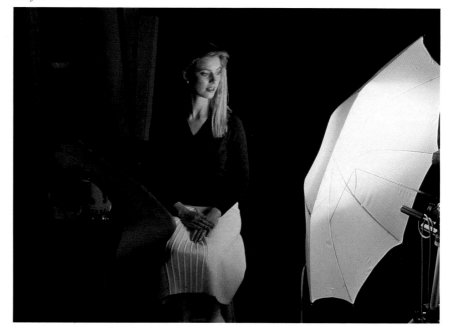

One of our illustrations shows a novel inflatable diffuser, but other than that, few diffusers are available for portable flash units. They are very easy to make, however, the prime requisite being translucent plastic material such as KODAK Lamp Diffusion Sheet, Rolux (a white opal flexible sheet available from theatrical equipment suppliers, or rigid white acrylic plastic such as plexiglass.

If the flash unit is affixed to a light stand, diffusion can be achieved by simply hanging a translucent sheet some distance in front of the flash head. The greater the flash-to-diffuser distance, the softer and broader the illumination. Accompanying illustrations outline procedures for more efficient and convenient diffusing sources.

Umbrellas as Diffusers

Photographic umbrellas made from translucent white cloth are available and are sometimes referred to as shoot-through umbrellas. They can be used as conventional bounce reflectors or as large diffusers in front of the flash.

The primary advantage of the shoot-through arrangement is the physical ease of positioning the light. Also, the intensity of the diffused flash is usually higher than the bounced flash. With the flash behind the umbrella rather than in front of it, the umbrella may be moved quite close to the subject. The closer the diffuser is to the subject, the more even the illumination, and, of course, the higher the intensity.

Above: a shoot-through umbrella acts as a diffuser when placed between flash and subject.

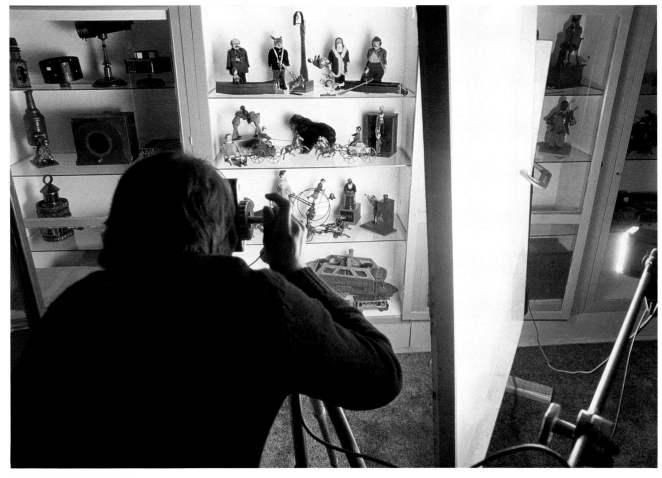

EXPOSURE FOR DIFFUSION

Automatic Mode

Physical positioning of the diffuser invariably blocks any sensor *on* the flash. Automatic exposure may be achieved with either a dedicated flash which has a sensor inside the camera or with a remote sensor which may be placed on the camera.

Diffusers decrease both the minimum and maximum automatic distance range of any flash. The amount of decrease very much depends on size and absorption characteristics of the diffuser. Therefore, use the flash confidence or sufficient light indicator, if your unit is so equipped, or perform a photographic test to determine the near and far range over which the remote automatic sensor can provide correct exposure with the diffuser in place.

Manual Mode

Unless you have a flash meter, the best solution is to shoot a bracketed series of exposure tests for the flash/ diffuser system at various distances. Record the results, then use the appropriate aperture whenever the diffuser is at a particular distance from the subject. Within reasonable limits the angle usually has little effect on the exposure.

A flash meter is ideal for these situations. Many commercial photographers even use instant film cameras fitted with special film backs to make absolutely sure of the results. The instant-film test provides both exposure and light-quality information. Once the test is satisfactory, conventional film is inserted in the camera for the final shot.

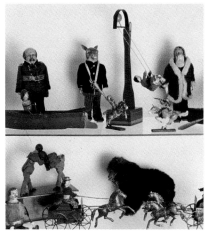

The large sheet diffuser helped to soften the light illuminating this collection. Notice in the detail immediately above how the gentle shadows help to establish form on these small subjects.

61

Multiple flash

Having experienced some of the blessings that one flash unit can provide, it's time to turn to the manifold joys of coordinating the output of several units. The possibilities are truly endless, as you'll soon see. For multiple flash, sophisticated units are not necessary. In fact, you may find that operating several rather simple models becomes a pleasurable and rewarding pastime.

With two or more flash units the possible lighting effects are limited only by imagination.

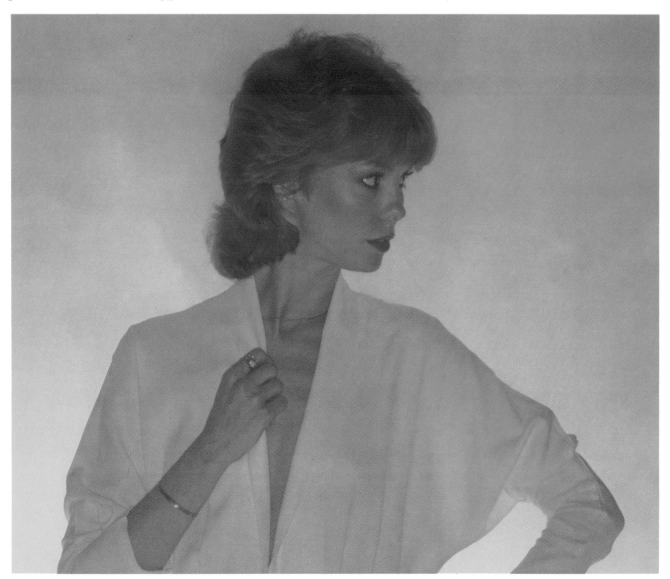

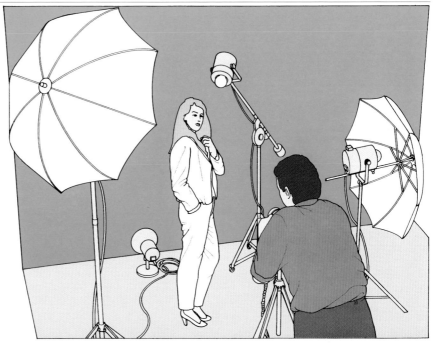

MULTIPLE FLASH UNITS

The directional quality of a single light source, even if bounced or diffused, can cause undesirable one-sided illumination. White or silver cardboard reflectors can be used to fill in shadows somewhat (see page 56), though with direct flash, certain parts of your subject may still lack adequate detail. A further limitation of bounce or diffused light is that its brightness is relatively weak, and it tends to engulf the entire subject, precluding the possibility of highlighting particular elements or areas. And finally, large scenes just cannot be illuminated adequately, either in intensity or uniformity, with a single electronic flash unit.

These problems can be overcome by using more than one flash. And while multiple flash is usually thought of as multiple *direct* flash, the best images may result from two bounce umbrellas, or three large diffusers, or four units bounced off a ceiling in a large room. In fact, any combination of direct and indirect flash can be used to achieve the picture you want.

Even just two electronic flash units provide considerably greater power and versatility than one, as well as the potential for creative techniques such as rim, back, and background separation lighting. The second unit need not be as powerful nor as sophisticated as the main flash. A very inexpensive, simple electronic flash is frequently the best choice.

A typical placement of four flash units is illustrated at right and above. The umbrella to the left of the photographer provides the main source of light. The small umbrella at the photographer's right fills in shadows created by the main light. The flash above the model helps to separate the model's hair from the background and the small light aimed at the background helps to separate the shadowed right side of the blazer from the dark background.

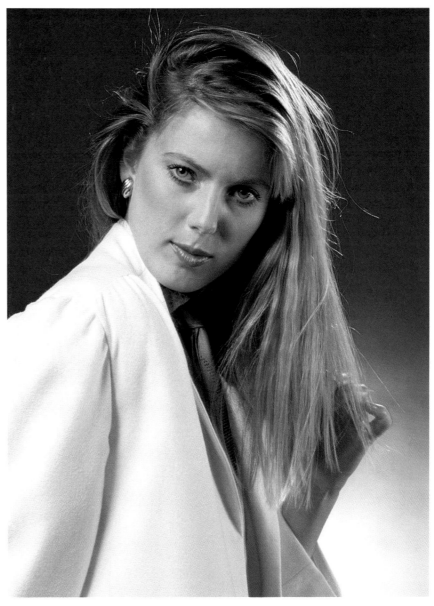

The photo below was lighted with one flash only from the left side. At right, another flash was added to fill shadows on the right side of the doll. The power in both flash units was adjusted so that the flash on the left provided more light than the closer fill-in flash on the right.

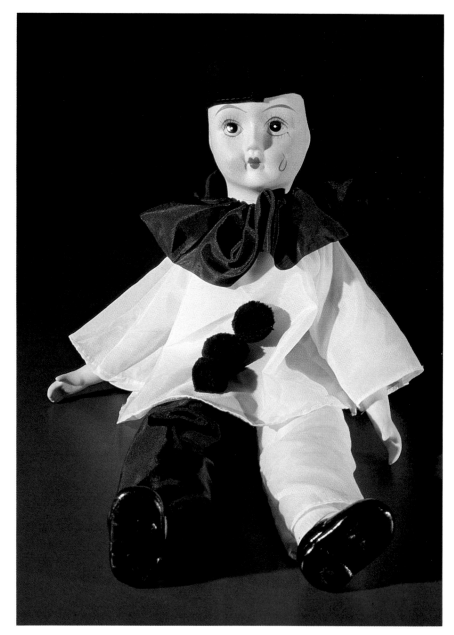

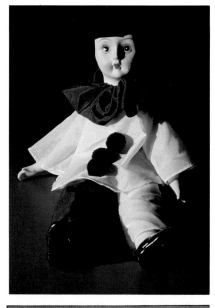

Mechanics

Triggering Two methods exist to fire multiple flash units simultaneously. The first is the hard-wire method which physically connects extension PC cords from each flash to a multiple connector, which is plugged into the camera flash outlet. Wires that

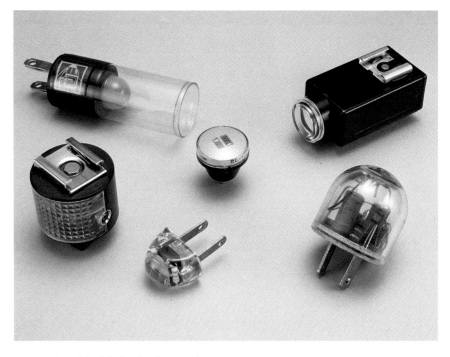

are easily tripped over and tangled make the hard-wire system a bit inconvenient. Furthermore, interconnecting different models of electronic flash may cause one or more of them to fire indiscriminately, or fail to fire at all when triggered.

A more reliable method requires a slave trigger—sometimes just called a slave. This device is a small photocell which connects with the flash PC cord or hot shoe. If another flash is fired in the vicinity, the photocell fires the flash to which it is connected. (Since light and electricity both travel at 186,000 miles per second, the delay between firing the main unit and the slave flash 25 feet away would be only 0.000000025 second!) At least one flash unit must be wired to the camera's flash outlet or hot shoe, and the slave triggers must be aimed to receive the light from the primary flash.

There are myriad ways of attaching portable flash units to surfaces other than the camera hot shoe, including spring clamps, C-clamps, and tripod connectors.

Mounting Multiple flash requires some means of supporting and positioning the additional flash units. Various stands, clamps, and swivels are shown in the accompanying illustration, though many successful photographs have been taken with flash units inelegantly taped to doors, chair backs, and shelves. What is important is secure placement and accurate aiming.

Although two flash units may be easily connected with hard wire and multiple socket arrangements, photoelectric slave cells are tidier and usually more reliable.

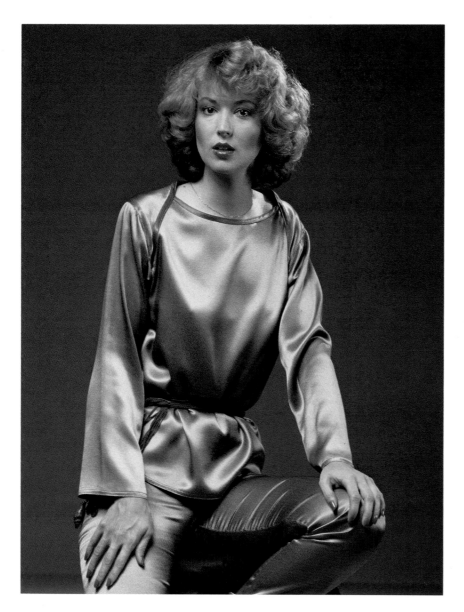

Main light left and above; fill light right and at head level; hair light at right and behind.

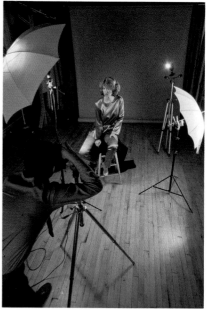

Light Placement

Endless combinations of light placement and lighting effects are possible with two or more flash units. The illustrations in this chapter present some of the possibilities—experimentation will suggest others. Note that cardboard reflectors can be quite helpful for filling in shadows and brightening dark corners or sides.

There is a temptation to aim several flash units directly at the subject, so that the second unit can fill in the harsh shadows caused by the first. The idea is to maintain the brightness inherent in direct flash and get more pleasing illumination. Unfortunately, *two* hard shadows are usually created by the two units. Don't hesitate to diffuse or bounce one or more of the main lights and use other flash units to illuminate the background or edges of the subject.

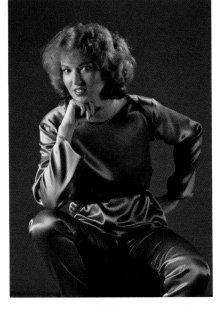

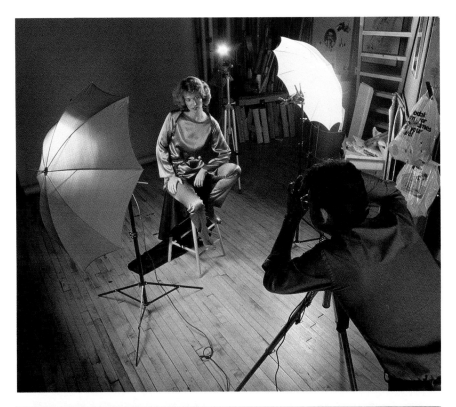

Main light at left, fill light at right, and hair light still behind on the right.

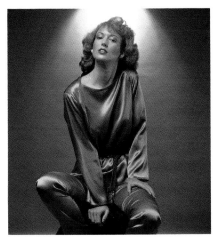

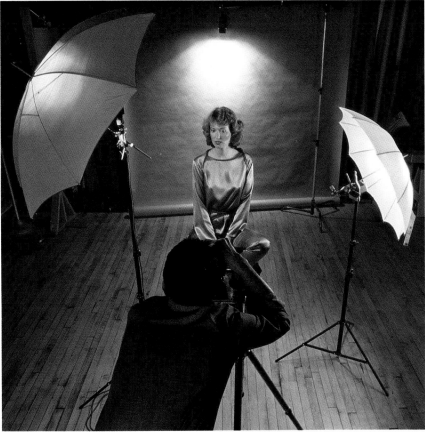

Main light at left and above; fill light at right and lower; light behind used to brighten background.

LIGHTING RATIOS

The brightness ratio between the main light and the fill light determines the lighting effects on your subject. How dark should the shadows be in comparison to the highlight (lighted) parts of the scene? A ratio of 8:1 (brightness of the main light to brightness of the fill light) is equal to a 3-stop difference and is fairly dramatic. A 2:1 ratio is relatively bland. Accompanying photographs illustrate various ratios; they are worthwhile studying to get a feel for balancing multiple lights.

Note that with color transparency films, it is advisable to use a somewhat lower lighting ratio than when negative materials are used. Transparencies have higher inherent contrast and, unlike prints from negatives, they cannot be burned-in or dodged in the darkroom to bring out deep shadows or overexposed highlights.

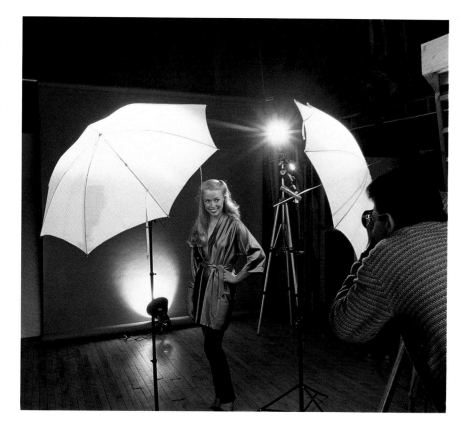

CONTROLLING INTENSITY

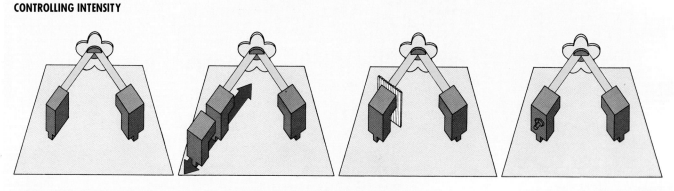

1. Each flash unit has its own maximum power output. Output varies by approximately 4 stops, or a ratio of 16:1 from the weakest to the most powerful portable equipment. Place your units according to their maximum output at the manual setting. Use the most powerful unit for the main light. Use a weaker unit for the fill light. Determine the difference in output and position for desired fill ratio.

2. In manual mode, flash-to-subject distance controls intensity at the subject. Because light intensity decreases in proportion to the square of increased distance, placing a flash twice as far from the subject as another flash of equal output results in a 4:1 flash ratio. The farther light is one fourth as effective in illuminating the subject as the closer light—a 2 stop difference. When 3 times as far from the subject, the farther light gives only 1/9 the intensity—a 9:1 ratio, or 3.2 stops less.

3. Diffusers can be placed over the flash to both decrease intensity and spread the light. (See page 43 for details.) And, of course, the light can be bounced off a reflective surface to lower intensity and spread out the light beam.

4. Some sophisticated flash units have add-on or built-in power output ratio controls. They permit the output (in manual mode) to be lowered from maximum to various fractions, typically ½, ¼, ⅛, 1/16 and sometimes even 1/32.

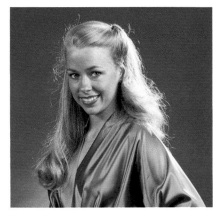

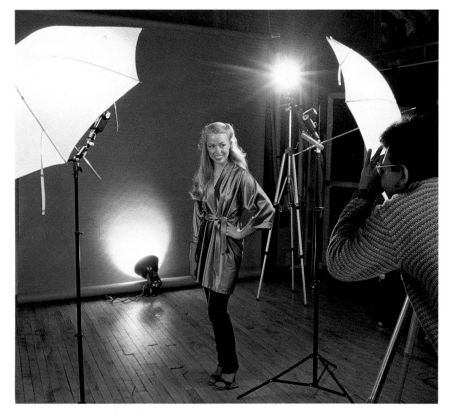

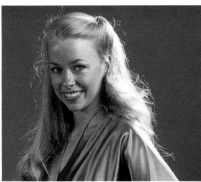

Placement of the lights can alter the ratio of light falling on different sides of the subject. **At top,** *lights of equal power were placed at equal distances to achieve a 1:1 ratio (both sides of the subject receive equal illumination).* **Above,** *a 2:1 ratio was gained by moving the fill light 1.4 times as far from the subject as the main light.* **Below,** *the fill light was moved twice as far from the subject as the main light for a 4:1 ratio.*

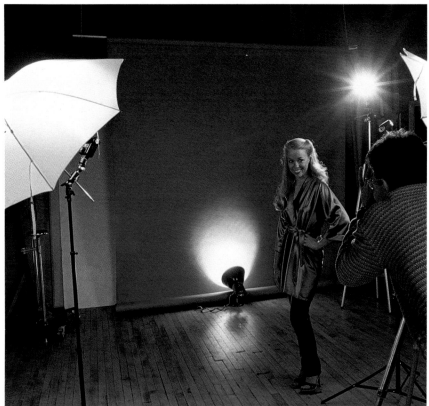

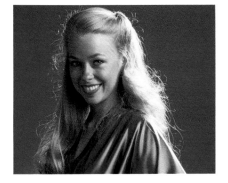

EXPOSURE

Exposure determination for multiple flash lighting is more complicated than for single-source setups. In fact, in almost all situations using more than one flash, automatic exposure control will probably *not* produce satisfactory, or controllable results. Automatic sensors are designed to provide proper main-light exposure, assuming only one source. But when other flash units are present, it is impossible to determine how they will affect the sensor on the main flash, or how the main flash will affect automatic sensors on the auxiliary electronic flash units.

Additionally, you are generally concerned with a particular *ratio* between main and auxiliary lights. Yet, for example, in automatic mode, a flash does not know that for this scene it is supposed to provide low-level, fill-in illumination—it insists on exposing normally. The solution is to operate all units manually, and use the guide numbers or a flash meter.

GUIDE-NUMBER SYSTEM

1. Position the main light first. If you're using direct flash, divide the guide-number by the flash-to-subject distance to find the lens aperture (see page 33). For bounced or diffused main light, determine the aperture as explained on pages 54 and 61, respectively. Set the camera lens at this aperture.

2. Next, determine the effect and intensity (with respect to the main light) desired from the first auxiliary unit. If it is to have intensity equal to the main light, its guide-number divided by its flash-to-subject distance must equal the aperture determined for the main flash. If you want the auxiliary unit to provide a 2:1 (main-to-fill) ratio—1 stop less intensity than the main light—position the auxiliary flash so its distance divided into its guide-number produces a number which is 1 stop larger than the lens aperture set for the main flash. Similarly, a 4:1 ratio requires 2 stops

Overlapping Light

A valid question when using multiple flash is, *"Doesn't an auxiliary flash add to the main light, and if so, shouldn't the lens aperture be closed down?"* The answer in most cases is that the auxiliary illumination is only filling in a shadow, adding a hair or rim light, or illuminating the background. Overlap onto the part of the scene lit by the main light is usually inconsequential. However, if two units are aimed in the same or close to the same direction, then, indeed, their outputs will add. In fact, two flash units are frequently placed together when additional brightness is needed. Two units of equal power at the same distance in manual mode double the light on the subject, permitting a 1-stop smaller aperture. For other combinations of equipment and distance, a flash meter or testing is necessary for acceptable results.

larger; 8:1, 3 stops; and so forth.

If you want the auxiliary light brighter than the main light—let's say a 1:2 ratio or 1 stop brighter—the distance/guide-number division must generate a number 1 stop smaller than the lens aperture setting. A 1:4 ratio requires a number 2 stops smaller.

3. When using auxiliary flash units that have variable power control, first determine the aperture suggested at full power when the flash is positioned conveniently. If that aperture is too small for the desired lighting ratio, don't move the flash. Turn down the power control to ½ for 1 stop less light, to ¼ for 2 stops less, to ⅛ for 3 stops, and to ¹⁄₁₆ for 4 stops. If the aperture suggested by the placement of the auxiliary flash is too large, move the light closer.

4. Additional auxiliary flash units should be set up, one at a time, as described in **2** or **3** above.

Background Lighting

Frequently an auxiliary flash can be used to light a background, either overall or in a small bright area behind the subject to provide tonal separation between subject and background. To determine proper exposure, consider the background as your subject in the flash-to-subject measurement, then proceed as in steps **2** and **3** above under "Guide-Number System."

For example: you require a flash-to-fill ratio of 2:1 using two identical flash units of guide-number 50.

Main light

Placing the main light 6 feet from the subject, calculate the required aperture by dividing the guide number (50) by the flash-to-subject distance (6). The aperture is *f*/8.

Auxiliary light

Follow instruction no. 2, left. You need an indicated aperture of *f*/5.6 (1 stop more than the main light) for a flash-to-fill ratio of 2:1. Therefore, divide the guide-number (50) by the aperture required (*f*/5.6). The result (9) is the appropriate flash-to-subject distance in feet.

Left and below: one way to separate the subject from the background is with a light aimed to lighten the background.

Above: a subject with dark hair is often lost in a dark background.

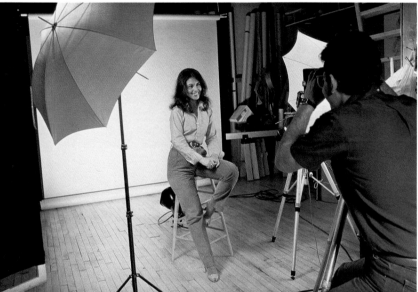

Above and at right: another way to relieve the dark edges of a subject from a dark background is to aim a small light at the subject's hair from behind.

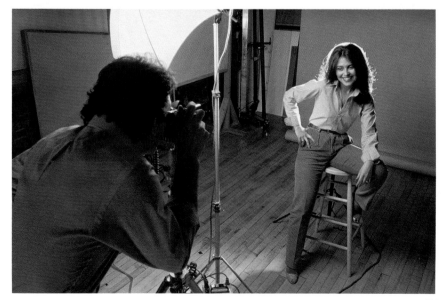

71

FLASH METERS

Using a flash meter takes the guesswork out of multiple-flash photography. By aiming the meter back at the camera, the photographer will get a fairly accurate incident reading from test firing the flash setup. At right, the main light is closest to the subject. The weaker fill flash is back near the camera. The meter accounts for any additive exposure effect from overlapping light sources. In this example, the connection between camera and flash units is hard-wired. The test is made by firing an empty camera. With a slave cell on the main flash, the photographer could make the test by firing the fill flash manually, without touching the shutter release.

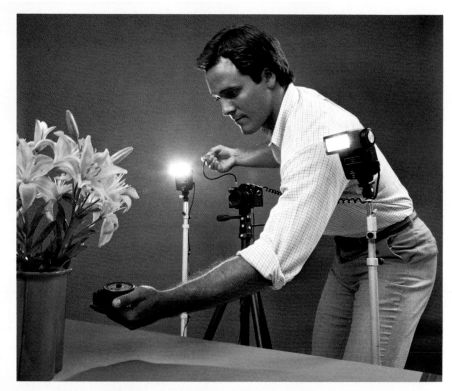

As shown on page 35, firing a flash set-up two or more times will provide more light for large or distant subjects or for greater depth of field. The meter at left will measure accumulated flashes. Every time the setup is fired, the readout value increases. Matching the final readout number to the f-number scale will give the f-stop for the total light output. In this example the setup was fired twice. The first flash would have required f/11. The second flash allowed f/16 for greater depth of field.

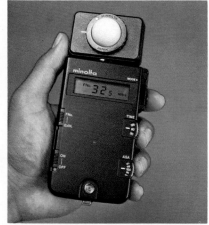

*The sophisticated meter shown **above** gives a direct LCD readout of the f-number required for the film speed and the power of the flash setup.*

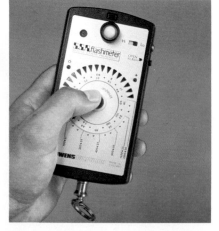

*The meter **above** indicates flash output by lighting one of the red wedges. Matching the lighted wedge with the adjacent scale gives the f-number to set on the camera.*

Instant Film Testing

Even when using guide numbers and flash meters, complicated multiple-flash photography is difficult to accomplish consistently to critical standards with small portable equipment. Why? Because you can't see what you're doing until the film is processed! Is light spilling where it's unwanted? Are shadows too dark or too light? Is there an obnoxious reflection from jewelry, glass, or metal? Are background and subject inseparable—too close in tonality? You might want to test any lighting setup before making an important shot.

Studio photographers avoid these problems in two ways: First they use flash units equipped with modeling lights. Modeling lights are relatively weak incandescent bulbs located close to the flash tube. Operating from 115-volt ac current, they generate a visible light pattern equal in quality, but not in brightness, to the flash illumination. The ratios among the modeling lights is the same as among the stronger flash units, so that lighting effects can be clearly seen at the camera position. Second, they make instant-film tests before committing themselves to shooting the final film.

Some professional-level portable flash equipment does accept add-on modeling lights for indoor situations to make accurate multiple-light control much easier.

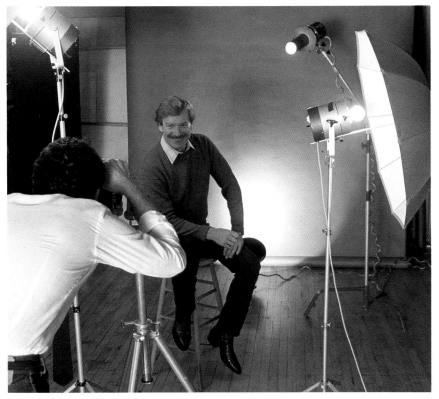

Because the effects of different light placement and exposure are often difficult to predict, it may be handy to make test exposures on instant print film.

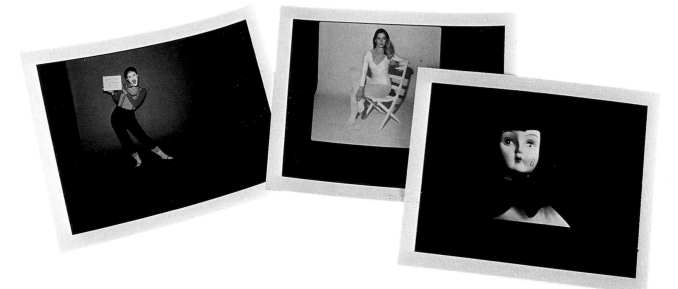

Flash outdoors

Although flash is primarily considered a tool for lighting indoor scenes where the ambient light is too dim for successful existing-light photography, you'll find it a useful and even exciting addition outdoors in the daytime or at night.

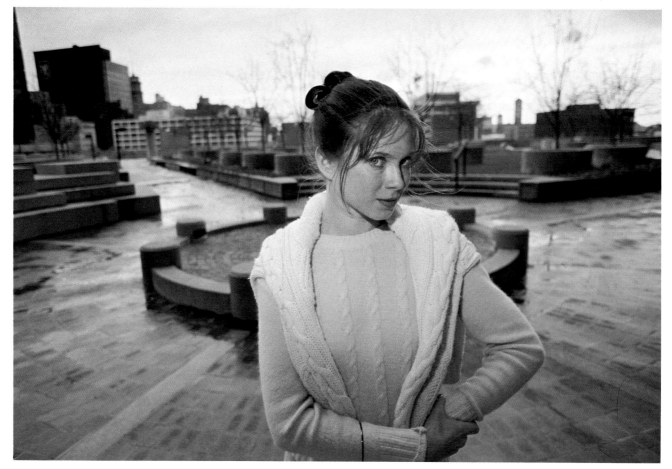

FILL-IN FLASH

Compared with the human eye, all films have considerably less ability to record detail simultaneously in both very dark shadows and very bright highlight areas. This limitation is somewhat more pronounced in slide films than in negative materials.

Flash can be used to brighten shadow areas so that details become apparent. Flash can also become a creative tool to tone down surroundings and spotlight subjects.

Outdoor lighting can often be improved with the judicious use of your electronic flash unit. Particularly in a backlighted situation, you'll find that if you expose for the background, your subject becomes a near-silhouette. If you expose for the subject in shadow, the background will become unattractively overexposed. The answer is to set your exposure for the background and add some flash to brighten the shadows on your subject.

Another case for fill-in flash occurs when your subject is located in front of a bright light source, such as a sunny window or door. Flash helps to balance exposure between background and subject.

You can create a dramatic image by spotlighting your subject with flash outdoors. Make sure that the sunlight is completely overpowered by the flash.

Equipment

Some care and effort is required to determine exposure for fill-in flash photography. If you are comfortable with the rules of general flash operation, fill-in flash procedures should be easy to follow. But they must be applied in a methodical manner!

Because the lens aperture must be correct for both ambient and flash illumination, fill-in flash is considerably easier if the flash equipment provides a choice of automatic-mode aperture settings or variable power control. And because the selected shutter speeds must be corrected for both ambient and flash illumination, fill-in flash is easier with leaf-shutter speeds. Focal-plane-shutter cameras are typically limited to synchronization speeds of 1/125 second *or slower.*

Flash Meters can help determine correct fill-in flash exposure and balance ambient and flash illumination. Automatic electronic flash units generally have a maximum of four allowable *f*-stops which restricts the ability to match the exposure required for the ambient light. But by operating the flash manually and using a flash meter, it is easy to read the flash intensity anywhere in the scene. And flash fill is not restricted to direct illumination. It can be bounced, diffused, or moved to provide the desired quality, direction, and intensity. A flash meter eliminates tedious calculations. Some of the more sophisticated meters read and integrate both flash *and* ambient illumination at various shutter speeds and provide convenient scales to assist in balancing each type of light for the desired effect.

EXPOSURE

1. In all cases, make a meter reading with your camera or a handheld meter of the area illuminated by the bright ambient light. The flash can be used to fill in the dark, shadowy areas receiving insufficient ambient light. Note the various combinations of aperture and shutter speed that provide correct exposure. (A good handheld exposure meter is particularly helpful since most display all possible exposure combinations simultaneously.)

 With a leaf-shutter camera, all shutter speeds may be used, though selecting one below 1/60 second usually requires a tripod or other support.

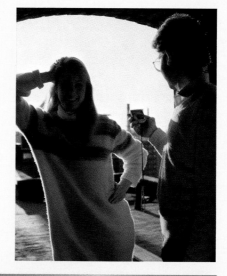
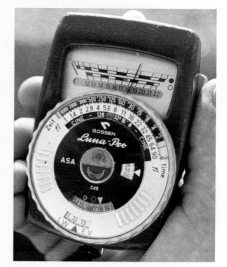

2. Decide whether the flash illumination should be darker than, equal to, or lighter than the bright-ambient light. An exact balance between flash and bright-ambient light often looks somewhat unnatural. More pleasing results can sometimes be obtained when the flash gives l stop less exposure than the ambient light.

3. Determine the lens apertures required by an automatic flash for the film speed or for the flash-to-subject distance if the unit is on manual.

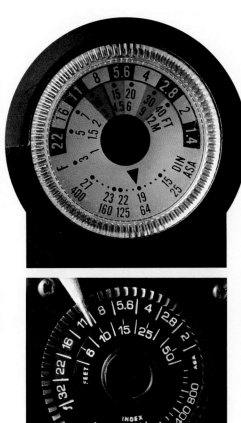

On manually operated flash equipment, the required aperture for the flash exposure can be modified by changing the flash-to-subject distance. *Aperture = guide number ÷ flash-to-subject distance*. The calculator dial on the flash shows various distance/aperture combinations.

Some electronic flash units have variable power settings for manual operation. At any given distance, the lens aperture depends on the power setting. Here, too, consult the flash calculator dial or a guide-number table.

4. Now compare the one or more lens apertures permitted by the flash and the shutter speeds permitted by your camera with the aperture/shutter-speed combinations previously measured for the bright-ambient illumination. With a leaf-shutter camera, match the flash-required aperture to the same *f*-number on the

EXPOSURE CALCULATION

Hand held exposure meter suggests ambient-light exposures of:

1/1000, *f*/2 ⟷ *f*/2.8
1/500, *f*/2.8 ⟷ *f*/4
1/250, *f*/4 ⟷ *f*/5.6
1/125, *f*/5.6 ⟷ *f*/8
1/60, *f*/8 ⟷ *f*/11
1/30, *f*/11 ⟷ *f*/16
1/15,* *f*/16 ⟷ *f*/22

The focal-plane camera used here synchronizes with flash at 1/125 second allowing these combinations:

1/125, *f*/5.6 ⟷ *f*/8
1/60, *f*/8 ⟷ *f*/11
1/30, *f*/11 ⟷ *f*/16
1/15*, *f*/16 ⟷ *f*/22
*Use tripod.

Above: Setting this automatic flash unit to the purple mode indicated that f/11 will give flash fill to equal the brightness of the sunlit background.

Left: For the aperture given by the exposure meter on the opposite page, the recommended flash-to-subject distance shown on this manual flash calculator is 10 feet, which would give equal exposure to subject and background.

list of bright-ambient exposures, then set the shutter speed required for correct ambient exposure at the chosen aperture. This provides flash exposure equal to the ambient brightness. See **5** overleaf for unequal balance.

The shutter speeds required for correct exposure of the bright-ambient illumination may be too high for synchronizing flash with a focal-plane camera. (For example, sunny day exposure for a film speed of ISO/ASA 100 is about 1/250 second at *f*/11 or 1/60 second at *f*/22.) Slowing the shutter speed requires a smaller aperture to avoid overexposure from the ambient light. The flash intensity then must be boosted to correspond to the smaller aperture. If possible, use an automatic flash setting for a smaller aperture. If manually operated, move the flash closer to the subject. If variable power, turn up the output. (See overleaf.)

With the automatic flash calculator shown here, use:

for balanced ambient and fill exposure:
blue mode
1/125, *f*/5.6 ⟷ *f*/8
purple mode
1/60, *f*/8 ⟷ *f*/11

for stronger ambient, weaker fill exposures:
white mode
1/125, *f*/5.6 ⟷ *f*/8, one stop difference
1/60, *f*/8 ⟷ *f*/11, two stop difference
1/30, *f*/11 ⟷ *f*/16, three stop difference
orange mode
1/125, *f*/5.6 ⟷ *f*/8, two stop difference
1/60, *f*/8 ⟷ *f*/11, three stop difference
yellow mode
1/125, *f*/5.6 ⟷ *f*/8, three stop difference

for weaker ambient, stronger fill:
purple mode
1/125, *f*/8 ⟷ *f*/11, one stop difference

With the manual flash calculator shown here:

for balanced ambient, fill exposure:
1/125, *f*/5.6 ⟷ *f*/8, subject at 17 feet
1/60, *f*/8 ⟷ *f*/11, subject at 10 feet
1/30, *f*/11 ⟷ *f*/16, subject at 7 feet

for stronger ambient, weaker fill exposure:
1/60, *f*/8 ⟷ *f*/11, subject at 17 feet, 1 stop difference
1/30, *f*/11 ⟷ *f*/16, subject at 10 feet, 1 stop difference
1/30, *f*/11 ⟷ *f*/16, subject at 17 feet, 2 stop difference

for weaker ambient, stronger fill exposure:
1/125, *f*/8 ⟷ *f*/11, subject at 10 feet, one stop difference
1/60, *f*/11 ⟷ *f*/16, subject at 7 feet, one stop difference
1/30, *f*/16 ⟷ *f*/22, subject at 5 feet, one stop difference
1/125, *f*/11 ⟷ *f*/16, subject at 7 feet, two stop difference
1/60, *f*/16 ⟷ *f*/22, subject at 5 feet, two stop difference

And sometimes with very strong ambient light and a relatively weak flash, it's just not possible, unless you get very close to your subject.

Conversely, when the bright-ambient illumination is weak, a relatively large camera aperture is required, whereas the flash may require a medium or even small *f*-stop. Here, if available, use an automatic flash setting for a larger aperture. If manually operated, move the flash farther from the subject. (You can always change lenses for a bigger subject image.) If variable power, turn down the output. You can also cut flash output by taping white tissue over the flash reflector. Generally two layers cuts the lighting 1 stop. Naturally, a diffuser, shoot-through umbrella, or bounce card would work as well.

5. To achieve unequal balance between flash and bright-ambient lighting, first decide whether the flash or the bright-ambient area should be normally exposed.

If the bright-ambient area is to be normal, choose one of the available lens apertures for the proper bright-ambient exposure. Now, depending on your equipment, set the flash's automatic aperture, or manual power, or manual distance so that the aperture required for correct flash illumination is 1 or 2 stops *larger* than the lens aperture set on the camera. Leave the lens aperture set for the bright-ambient light exposure. The photograph will have a normally exposed bright-ambient area and a flash-illuminated area that is 1 or more stops darker.

Conversely, to spotlight the flash-illuminated subject against a *darker* ambient area, do the following. Set the lens aperture as required by the flash for a normal flash exposure. Now set the shutter speed so that the combination of lens aperture and shutter speed produces an exposure 1 stop (or more) *less* than required for a normal rendition of the bright-ambient area.

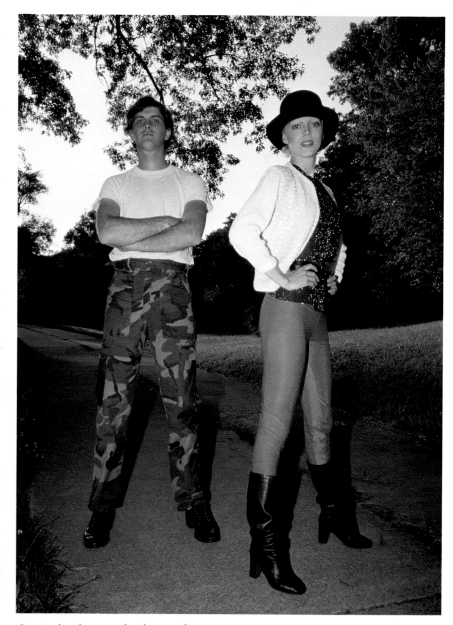

Late in the afternoon, the photographer dramatized this unusually clad couple by overpowering the sunlight exposure with flash. The underexposed background offers a less distracting setting than if fully exposed.

FLASH OUTDOORS AT NIGHT

Photographing outdoors at night is similar to taking pictures in a giant, totally black room. Tremendous potential exists for unusual, often stark visual effects because there are no light-colored ceilings or walls to reflect light—just black, empty space. There's even the opportunity to leave the shutter open in this black space and, totally disconnected from the camera, firing the flash at will, one or more times per frame.

About the only real difficulties are the problems of focusing and of setting camera and flash controls in the dark. If possible, have a human subject point a flashlight at the camera (or hold a match), and focus on that small, bright light. The same flashlight can be used by the photographer to compose the shot. It's also possible to focus using the distance scale on the lens barrel. For this and other operations with the flash and camera controls, a small flashlight is most useful.

You'll appreciate the help at night if you mount your camera on a tripod and attach a cable release. The steady support becomes an absolute necessity when you make multiple exposures or paint with flash.

Exposure

If the subject is small in relation to the overall scene, automatic flash sensors may cause overexposure. If you can, conduct some exposure tests. Otherwise bracket by closing the lens down ½ to 1 full stop less than called for by the setting on the flash unit's automatic sensor. (With a dedicated flash, activate the underexpose control on the camera, if it is so equipped.)

On the other hand, manual guide numbers are usually based on proper exposure for an average room. Outdoors, results may be slightly underexposed. Again, do a test, or bracket by giving at least ½ stop additional exposure.

Outdoors at night you'll find a perfect studio setting, with few or no distractions. A fairly close subject will stand out as if posed on black seamless paper. An automatic flash unit will provide good exposure for nearby subjects. Increase exposure by ½ to 1 full stop for a manual flash unit.

This photographer enlisted the aid of several friends to make a multiple flash photograph with a single flash unit. One friend held the camera shutter open, but covered the lens between flashes. Other friends then placed themselves in compositionally agreeable locations. The photographer fired the flash manually at each friend from a nearby position that wouldn't trap his silhouette between flash and camera. The building in the background was illuminated by firing the flash several times from different spots near the facade.

For this unusual scene, the photographer made a time exposure that showed star trails and features of the house. A confederate fired a flash unit inside the house on signal to illuminate the windows.

PAINTING WITH LIGHT

A tiny flash can be used to light a huge area if the subject is stationary or outdoors on a very dark night *or* the camera has the ability to make accurate multiple exposures on the same frame, and you have lots of time and patience.

The camera must be on a sturdy tripod. Each blast of light from the flash covers one small area of the scene—a little practice helps prevent overlap or underlap. However, you must be careful to position yourself and the flash so that neither blocks any part of the scene from the camera. If your camera can't make accurate multiple exposures, have an assistant hold a dark card or hat over the lens between flashes. The shutter will remain open on the B or T setting throughout the full series of flashes.

Operate the flash in manual mode, and position it the same distance from the subject for each shot. Dividing the guide number for that distance provides the correct lens aperture. (Overlap, incidentally, causes overexposure, whereas underlap creates dark spots between the areas lighted by flash.)

It took almost half an hour to record this marvelous home with a single flash unit. An assistant covered the lens between flashes. Because of the many flashes required, the photographer was careful not to overlap the light beams which would have resulted in uneven exposure.

FLASH AND FILTERS

Overall subtle or strong colors can be added to a scene by placing colored filters either over the camera lens or flash head. Though glass or optical-quality gelatin filters are required in front of the lens, considerably less expensive acetate theatrical or photographic color printing CP filters can be taped over the flash. Additionally, many flash manufacturers offer inexpensive color filter kits to fit their flash heads.

Unusual, even bizarre effects are possible when filters are used in conjunction with fill-in flash. One can put a filter on the flash only, or filter both the flash and the lens. Painting-with-light techniques (see page 83) also offer the opportunity to change color with each firing of the flash. Accompanying illustrations demonstrate some possibilities.

Tape a filter over your flash for unusual renditions of familiar subjects.

Attaching a green filter to the flash gave an amusingly ghoulish appearance to these ice cream lovers. By using an automatic mode that required a large aperture, the photographer was able to record the background with a normal exposure and color rendition.

COMPLEMENTARY COLORS
Use the color wheel pictured above to choose complementary filters to attach to your camera lens and flash head as shown below. Select a color for lens or flash and then find its complement on the opposite side of the color wheel above.

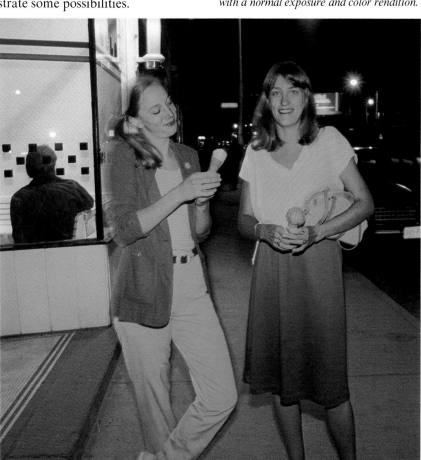

A white horse can become a pallet for your filter collection when you filter fill-in flash. The background, unaffected by the flash, remains perfectly normal.

Attaching complementary filters to flash and lens will give normal color rendition to the flash subject, while allowing the background to be influenced only by the filter attached to the lens.

Close-up
flash photography

When you move very close to a subject, you'll often find that you want very small apertures for maximum depth of field. Since small subjects can move as fast as larger ones, you'll also want action-stopping capability. Naturally, it helps to be in a position to control the illumination—not always possible with existing-light photography. Electronic flash can solve your dilemma.

An extreme example of close-up photography. The small objet d'art is shown next to a same-size slide portrait. This is a 1:1 reproduction ratio, where the image on film is the same size as the object photographed.

Frequently the technical problems encountered in close-up photography strongly recommend electronic flash as the primary source of illumination. Shallow depth of field, an inescapable fact of life when focusing close, requires apertures of $f/11$, $f/16$, or smaller. Such tiny lens openings, in turn, demand slow shutter speeds. But high image magnification leads to corresponding magnification of the slightest camera vibration or subject motion, and slow shutter speeds aggravate the situation. Electronic flash, however, provides more-than-sufficient intensity for close-up subjects at the smallest apertures, and its short duration arrests all but the most severe motion.

GENERAL TECHNIQUES

The most significant departure from standard flash photography lies in determining exposure. While the procedures required to arrive at the proper aperture for a given lens/flash/image-magnification combination are fairly straightforward, various possible combinations and characteristics of equipment—each demanding different exposure technique—require lengthy explanations beyond the scope of this book. The following considerations will give you a good starting point, applicable to generally available equipment.

EQUIPMENT

1. When a nonzoom lens is extended relatively far from the film to focus close-up, there is a loss of light at the film plane that increases as the magnification of the image increases. (For example, if the image size on the film is life size—as big as the actual subject—light loss is *2 full stops*!) Such compensation is required with single-focal-length lenses on extension tubes or bellows, and with *non*zoom macro lenses. Instructions for close-up equipment should give exposure compensation data. (If your macro lens is one of the few that has internal focusing, check the instruction manual for exposure compensation suggestions.)

There is usually no need for exposure compensation with close-focusing zoom telephoto lenses.

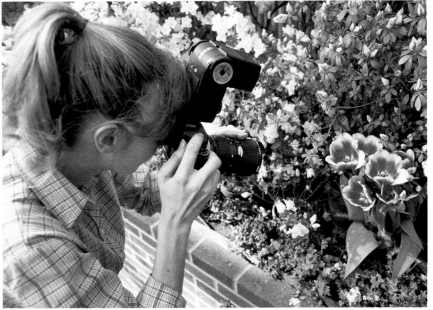

2. Close-focusing zoom lenses do not usually require exposure compensation in their close-focusing mode. If in doubt, check the lens instruction manual.

3. Dedicated flash equipment, combined with a camera that reads through-the-lens *flash* exposure will automatically compensate for lens extension, unusual flash placement, and bounce lighting. Such a combination of flash and camera is extremely convenient for close-up work. When the flash is aimed directly at the subject, however, do not violate the minimum flash-to-subject distance permitted for your particular flash unit.

4. Nondedicated automatic flash can be used for close-up photography, *if*, as above, the minimum flash-to-subject distance is not violated, and if the flash sensor can be positioned near the camera lens. If exposure compensation is required for lens extension, the lens aperture will have to be set larger than the flash stipulates. (See formula on page 89.) Unfortunately, automatic flash usually specifies large-to-medium apertures and adequate depth of field in close-up photography generally requires small apertures.

5. Small, low-power flash units are ideal for close-up applications. In fact, for direct flash photography, an inexpensive unit having a guide number of 35–45 for a film speed of ISO/ASA 25 is perfect, particularly for slow, fine-grain films. It should be capable of manual operation so that you can control lens aperture and exposure compensation. There are small flash outfits—flash units on brackets and ring lights—that are designed for close-up photography.

Below: getting close with a macro lens will mean that you'll have to reduce the flash output. One good way is to bounce the flash off a card. The bounced flash will also give light that may be more attractive than direct flash.

Above: for variable lighting effects, use two small flash units to provide main and fill light. Make one flash dominate by covering the other with tissue.

At right and far right: using a ringlite gives soft, widespread illumination to small, close-up subjects. Compare the results on the opposite page—the purplish cluster at far right was captured with a small flash unit held off to one side. The same cluster at right was recorded with a ringlite.

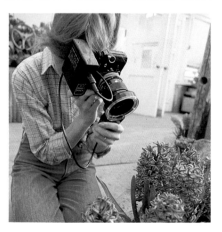

EXPOSURE TEST

1. Place the camera on a tripod and the subject—which should be medium-toned—in a fixed position.

2. Load the camera with your standard film and place the flash in whatever position is required to obtain the desired lighting effect. (In close-up work, aim the flash very carefully!)

3. If the flash will be used in its automatic mode, be certain the minimum flash-to-subject distance is not violated (don't hesitate to move the flash back and away from the camera). However, with bounce or diffused flash and a remote sensor near the lens, the unit can usually be placed 25 to 50% closer than the minimum recommended distance.

4. Now make a series of bracketed exposures at various lens-to-subject distances. Bracket by full stops.

For example, with an automatic flash, start at the aperture recommended on the calculator dial, say $f/8$. With a measured 20-inch lens-to-subject distance, make exposures at $f/32^*$, $f/22^*$, $f/16$, $f/11$, $f/8$, $f/5.6$ and $f/4$. Next, move the camera so the lens-to-subject distance is 15 inches. Focus and make the same series of exposures. Continue toward the subject in 5-inch increments until the lens will focus no closer.
*If possible

To find a starting aperture at each magnification for bracketing with a manual flash, divide the guide number (see page 33) by the accurately measured flash-to-subject distance. (Since most guide numbers are calculated using distances in feet, flash-to-subject distance must be measured in feet.)

In all cases, take careful notes on exposures and physical placement of flash and lens. Some methodical photographers place a small card with all applicable data in the scene (if it fits), so that a numbering mistake by the processing lab won't harm the test.

5. Process the film normally, then carefully examine the negatives (not prints) or slides. Record the best exposure for each lens-to-subject distance, and make a small chart to tape onto the flash. (The best exposure may fall between the full-stop brackets.)

From now on, use that chart of lens-to-subject distance vs aperture for all close-up photography using the same lens, film, flash, and flash position.

While the test does take some time, you can work very quickly and very accurately once the chart is made.

Close-Up Exposure with Flash Meters

Flash meters (see pages 58 and 72) are particularly useful for close-up photography because, as we mentioned before, it is frequently not possible to use a flash in its automatic mode, and manual close-up flash calculations may be complicated.

When no exposure compensation is required for lens extension, the reading provided by the meter can be used directly. Such situations include the use of close-focusing zoom lenses, some internally focusing macro lenses, and any nonclose-up lens to which supplementary close-up lenses have been added.

Use of extension tubes, bellows or most conventional macro lenses requires a correction to the meter's suggested aperture (f_m) First, determine the magnification (M) by dividing the short dimension of the scene into the short dimension of the film frame (35 mm film has a 1-inch-wide frame). Some macro lenses have scales that show M directly. The correct aperture (f_c) to set the lens at is simply

$$f_c = \frac{f_m}{M + 1}$$

In this example, the short dimension of the scene is 1 inch. To find M:

$$M = \frac{1}{1} = 1$$

If the recommended aperture is $f/8$ you'll have:

$$f_c = \frac{8}{1 + 1} = f/4$$

Freezing motion

Because the longest duration of an electronic flash is typically 1/1000 second (as fast as your fastest shutter speed), you'll find that electronic flash can capture images of fast-moving subjects that even your eye cannot provide. Some units with auto or power control capability may even provide a flash as short as 1/30,000 second—an excellent speed for recording the very quick.

The ultimate in high-speed flash photography—a small missile pierces a light bulb in a matter of milliseconds. This is probably not possible for most flash photographers, but there are dozens of other exciting motion-stopping opportunities, as you'll see in the next few pages.

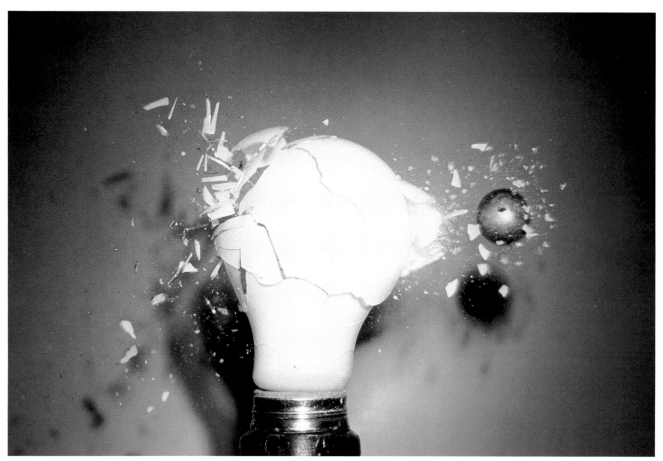

It is quite easy to create striking, informative, and beautiful images by capitalizing on the short, motion-stopping duration of electronic flash. Though the shutter speed on most focal-plane-shutter cameras must be set at around 1/60 second to properly synchronize with flash, the actual exposure time of the image on the film is governed by the burst of light from the flash, typically 1/1000 second.

In fact, 1/1000 second is the *longest* duration for most camera-mounted units and occurs when fired at maximum output. At lower output settings, you'll find that flash durations of 1/10,000, 1/20,000 and sometimes even 1/50,000 second are available, the shortest burst occurring at the minimum output. (The brightness of the flash remains the same at any output setting—only the duration of the flash changes.)

Flash duration can be regulated by either using the variable power control on the flash, if it is so equipped, or by placing the subject close to a flash operating in the automatic mode. In the second case, the closer the subject (up to the near limit permitted by the automatic sensor) and the larger the aperture, the shorter the duration (see page 27).

It is obvious that only small scenes close to the camera can be photographed at the shortest duration, since power output governs duration. But frequently 1/10,000 second or so is more than adequate to arrest some types of animal or human motion. This flash speed can usually be achieved if the scene covers an area about 8 by 12 feet and if an automatic flash is set at its largest aperture mode. (Medium-to-high-speed films, ISO/ASA 100 to 200, are useful here to obtain adequate depth of field.)

Of course, larger areas can be illuminated by using a number of flash units set on low power, all triggered simultaneously by slave cells. (For most purposes, assume that slave cells have no delay which could cause a problem with high speed subjects [see page 65]. In such situations, a flash meter can help you determine exposure.)

It's easy to freeze most human or animal motion with an automatic flash unit, a dark background, a high-speed film, a large aperture, practice, and anticipation.

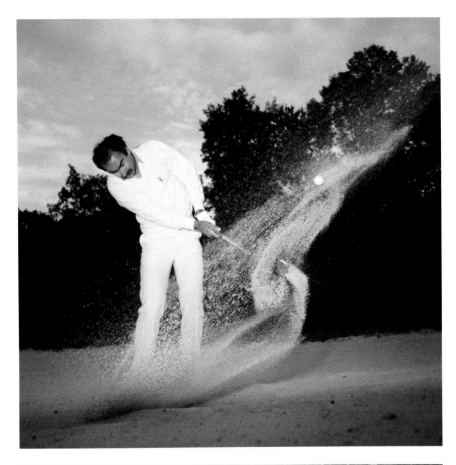

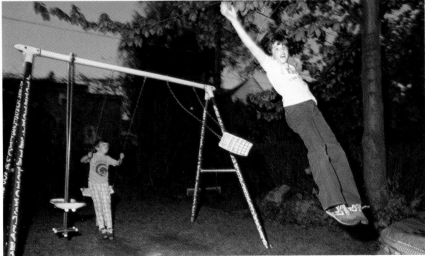

Triggering

Photographing a spinning electric fan or a pirouetting ballerina requires no special triggering—look through the viewfinder and fire when appropriate. Anticipating the "decisive movement" slightly is helpful, since there is a delay caused by our relatively slow human reflexes and by the mechanical delays in the camera.

Other subjects—flying insects, dropping projectiles, racing rodents—are moving so rapidly past the camera that the flash must be electrically or mechanically triggered at the exact instant the subject moves in front of the lens. And since the camera shutter takes too long to open, these events must be staged and photographed in a totally dark room with the shutter locked open. The brief flash acts as the shutter.

Any flash can be fired by electrically connecting the two wires (or their extension) found inside the PC cord. This is called contact closure. Anyone familiar with basic electronics (ham radio operators, TV repairpersons, appliance technicians) can devise a flash trigger appropriate for the event from a relay activated by a trip wire, microphone signal, broken light beam, or even a light touch. However, no one but authorized flash technicians should attempt to work on the *inside* of a flash unit—**severe shock hazards can result!**

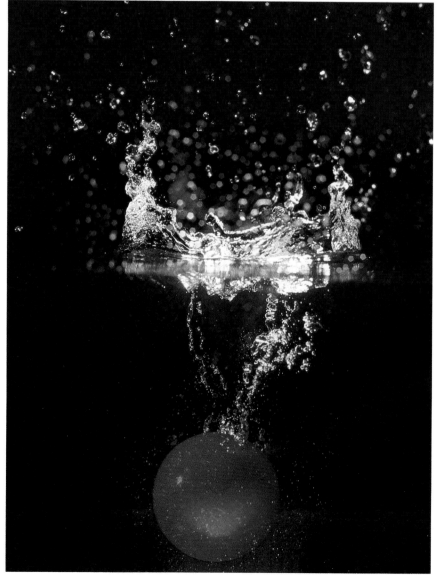

The sound trigger shown above would help to record the exact moment of impact of the rubber ball striking the water seen at right. Without a sound trigger or photoelectric cell you'll want to practice before exposing any film. Try to synchronize the action with pressing the shutter release or firing the flash manually.

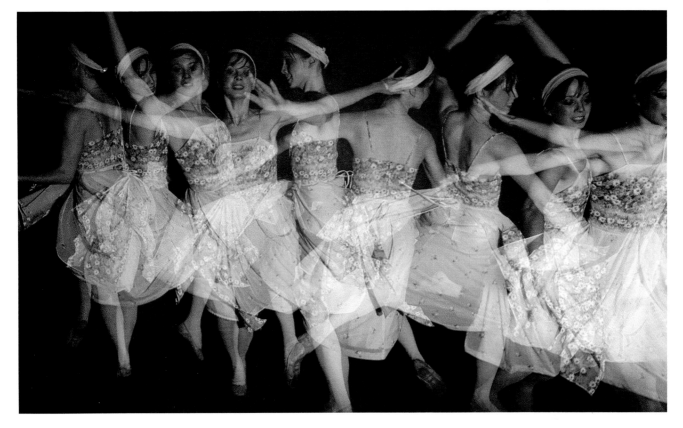

STROBOSCOPIC EFFECTS

Stroboscopes are electronic flash units that give a repetitive series of short-duration flashes. Though most people are familiar with the simple stroboscopes used to create psychedelic effects in discos, there are lesser known models designed for photography that have controls to vary repetition rates, and sometimes even light intensity.*

To achieve satisfactory results, considerable patience and trial-and-error tests are required to find the perfect repetition rate and to coordinate the beginning and end of the sequence. (Instant-film tests can be extremely helpful.)

This work also requires a totally dark room with a black felt backdrop. And, of course, lock the shutter open for the full duration of the sequence.

Balance the effects of exposure on parts of the subject that receive repetitive flashes and parts of the sub-ject that receive only one flash in each position. Areas receiving repeated flash illumination probably will be a bit overexposed (the effects are cumulative) and areas that get only one flash will be a bit underexposed.

*Some manufacturers and distributors of stroboscopic equipment appropriate for photographic applications are given below. Kodak does not endorse the products sold or manufactured by the organizations shown in this incomplete list.

Wein Products, Inc.
115 West 25th Street
Los Angeles, CA 90007

Edmund Scientific Corp.
101 East Gloucester Pike
Barrington, NJ 08007

Times Square Theatrical Supply Co.
318 West 47th Street
New York, NY 10036

and in the U.K.:

Pulsar Light of Cambridge Limited
Henley Road
Cambridge CB1 3EA
England

By setting an automatic flash unit to the autowinder mode and using fast film with a large aperture, the photographer made this motion study of a dancer. The low power setting made it possible to fire the flash rapidly many times while keeping the shutter open. Needless to say, the background was extremely dark to avoid ghost imaging from the ambient lighting.

Recommended reading

If you have enjoyed this Kodak book, you're in luck. There are dozens of other Kodak books that can furnish the same enjoyment. Some are general books that treat a large body of information and others are specific books like *Electronic Flash* that deal with one topic only. You'll find myriad ideas, thousands of techniques, and new and different approaches to multitudes of subjects. Illustrations and text combine to present these photographic thoughts in a crisp and straight-forward manner.

Ask your photo dealer for these publications. If your dealer cannot supply them, you can order by title and code number directly from Eastman Kodak Company, Department 454, Rochester, New York 14650. Please enclose payment with your order, including $1.00 for handling plus applicable state and local sales taxes. Prices are subject to change without notice.

Using Filters
KW-13, $8.95
This new KODAK Workshop Book explains how filters work and how they can be used for improved results with color and black-and-white film. It shows how filters can help to reproduce realistic colors and monochromatic tones. Filters and lens attachments can also be used creatively to augment elements of a scene or subject, and this aspect of filter photography is given close attention. With more than 160 illustrations *Using Filters* should give you enjoyable reading and many more photographic avenues to explore. *96 pages.*
ISBN 0-87985-277-1

The Joy of Photography
AC-75H (hardcover), $19.95
AC-75S (softcover), $11.95
A thorough guide for both the beginning and advanced photographer, this book covers the technical and creative aspects of photography. It carries you from camera handling into the darkroom, delves into photographic equipment, and explores the many ways of building a picture. Landscapes, sports, nature, and people are also studied. *302 pages.*
ISBN 0-201-03916-8 (Hardcover)
ISBN 0-201-03915-X (Softcover)

KODAK Guide to 35 mm Photography
AC-95H (hardcover), $19.95
AC-95S (softcover), $9.95
Loaded with photographs, this book will familiarize you with camera handling, Kodak films, exposure, flash, equipment, composition, and more. The pictures show you where it's at. The text shows you how to get there. *288 pages.*
ISBN 0-87985-242-9 (Hardcover)
ISBN 0-87985-236-4 (Softcover)

Professional Photographic Illustration Techniques
O-16, $7.50
Aimed squarely at the photographer who wants more from a controlled studio atmosphere, this book explores simple and sophisticated lighting, subject approach and handling, and many helpful tips and techniques designed to overcome the barriers of inexperience. Much material comes directly from contemporary illustrators. More than 140 color illustrations, most accompanied by lighting diagrams and descriptive captions written by the photographers themselves. *136 pages.*
ISBN 0-87985-190-2

Adventures in Existing-Light Photography
AC-44, $4.00
High-speed film, a camera with a fast lens, and this colorful 80-page guide are all you need to take exciting, uncontrived pictures anywhere, anytime without the need for additional artificial light. It's packed with hundreds of ideas you can use to take pictures at home or traveling, indoors or outdoors. Includes easy-to-use exposure tables and advice on films and processing. *80 pages.*
ISBN 0-87985-251-8

More Joy of Photography
AC-70H (hardcover), $24.95
AC-70S (softcover), $12.95
This is the book for the photographer who likes creative techniques. The first two chapters tell you how to develop your own personal creative style and how to use camera controls creatively. A third chapter explodes with 100 creative techniques covering topics like painting with flash, handcoloring photographs, using time lapse, and photographing mirror reflections. *288 pages.*
ISBN 0-201-04544-3 (Hardcover)
ISBN 0-201-04543-5 (Softcover)

Professional Portrait Techniques
O-4, $9.95
For anyone who loves elegant portrayal of people, this book explores some of the best in contemporary portraiture. Lighting, make-up, techniques, and individual photographer's philosophies give this volume real impact. Richly illustrated with work from famous portraitists from around the world. Their comments frequently enliven the techniques under discussion. *116 pages.*
ISBN 0-87985-247-X

Index

AC adapter 22
AC operation 22
Action30, 86
Automatic flash . . 15–17, 19, 26–28, 30
 32, 36, 39, 40, 43, 44
 48, 53, 56, 58, 61, 70
 77–81, 84, 87, 89, 91
 93
Autowinder 21, 93
Background light67, 70, 71
Bare-tube flash 57
Batteries 15, 18, 19, 21, 44
 AA . 21
 alkaline 21
 C . 21
 charger 22
 external battery pack 21
 510 volt 21
 low voltage disposable 21
 nickel cadmium 22
 rechargeable 21, 22
 storage and maintenance 21
 tester 21
Bounce flash 10, 30, 32, 35, 43
 49–58, 60, 63, 66, 68
 77, 79, 87–89
Bounce surface 51–54, 56, 58, 60
Capacitor 15, 19, 21, 22, 36
Cardboard reflector . .9, 49, 54, 56, 63,
 66, 79, 88
Close-up photography 17, 30, 49,
 86–88, 89
Color balance 25
Complementary filters 12, 84, 85
Confidence light 17, 52, 53, 61
Contact closure 92
Coverage 25, 42
Daylight balance 25
Dedicated flash . . 17, 19, 24, 28, 30, 43
 48, 53, 61, 81, 87
Depth of field 44, 52, 86, 87, 91
Diffuser35, 43, 58–61, 68, 79
 inflatable 60
Diffusion58, 59, 61, 63, 66, 77, 89
Energy supply 20, 21
Fill-in flash 13, 24, 32, 35, 57, 63
 64, 66, 75–78, 84, 85
Fill light66–70, 88
Film latitude 37
Film speed 19, 24, 28, 32, 33, 37
 38, 53, 78, 79, 88
Filters 12, 25, 84, 85
Flash calculator . . 27, 28, 32, 33, 36, 38
 79, 89
Flash cord 18, 32

Flash meter54, 61, 70, 73, 77, 89, 91
Flash range 19, 25, 27–29, 33, 44
 48, 52
Flash range/automatic mode . . .19, 28,
 29, 36
Flash synchronization switch 19
Flash test 36–38, 56, 58, 61, 89
Flash-to-subject distance . . 24, 27, 28,
 32, 33, 37, 38, 48, 53,
 56, 68, 70, 87, 89
Flash tube15, 25, 57
Flash umbrella 54–56, 60, 63
 shoot-through 60, 79
Focal-plane shutter 24, 27, 77, 79
Fresnel lens 43, 44
Guide number . . . 33, 36, 38, 39, 41, 43
 44, 45, 48, 54, 56–58
 70, 79, 81, 88, 89
Guide number formula 38
Guide number test 38
Hairlight 66, 67, 70, 71
Hot shoe 15, 18, 19, 23, 65
Incident light 58
Instant film test61, 73, 93
Instruction manual 20, 23, 25, 26, 28, 32
 33, 36, 42, 43, 87
Leaf shutter24, 77–79
LED/LCD17, 58
Lighting ratio68–70, 73
Main light ·. . .66–70, 88
Maintenance 20
Manual flash . . . 19, 26, 27, 32, 33, 35
 36, 38, 40, 41, 43, 44
 48, 53, 54, 56, 57, 61
 70, 77–81, 83, 88, 89
Maximum/minimum flash range . . 19,
 28, 43, 44, 53, 61
Modeling light 73
Motion90, 91, 93
Motordrive 21
Multiple exposure 13, 16, 82, 83

Multiple flash . . . 10, 32, 35, 62, 63, 65
 68, 70, 73, 81, 82
Negative film 36, 37, 68, 89
Normal lens 25, 42, 43, 44
Off-camera flash 9, 17, 46–49
 55, 56
Painting with flash 12, 81, 83, 84
PC cord23, 65, 92
Readylight19, 22, 36
Recycle 16, 19, 21, 22, 36
Reflection 39
Reflector (part of flash) 15, 45
Reforming the capacitor 21, 22
Reproduction ratio 86
Rim light 70
Ringlight 88
Sensor 16, 17, 19, 27, 28, 32
 33, 36, 37, 39, 40, 43
 48, 53, 58, 61, 70, 81
 87, 91
 remote sensor 48, 53, 56, 61, 89
Sensor-automatic flash 19, 28, 30
Shadow detail 36
Shutter speed 19, 24, 27, 28, 32, 37
 77–80, 87
Slave trigger 65, 91
Slide film (transparency film) . . .36, 37,
 40, 68, 89
Sound trigger 92
Stroboscope 93
Sync cord 23
Synchronization . . 23, 24, 27, 32, 77, 79
Synchronization outlet 23
Telephoto lens 25, 42–45, 87
Tilting flash head 50
Time exposure 82
Transparency film (slide film) . . . 36, 68
Trip wire 92
Wide-angle lens 25, 42–45, 60
X-synchronization 23
Zoom flash head42–45

METRIC DISTANCE EQUIVALENTS

If you know:	Multiply by:	To get:
inches	25.4	millimetres
	2.54	centimetres
	0.0254	metres
feet	304.8	millimetres
	30.48	centimetres
	0.3048	metres
yards	91.44	centimetres
	0.9144	metres
miles	1.60934	kilometres

FILM SPEED EQUIVALENTS: ISO/ASA TO ISO/DIN

ISO/ASA	ISO/DIN	ISO/ASA	ISO/DIN
12	12	320	26
25	15	400	27
32	16	500	28
40	17	650	29
50	18	800	30
64	19	1000	31
80	20	1250	32
100	21	1600	33
125	22	2000	34
160	23	2500	35
200	24	3200	36
250	25		

HELP US BUILD BETTER BOOKS!

(And *help yourself* to a free subscription to KODAK Photonews ... the newsletter that gives you current information about Kodak products along with tips on how to take better pictures.)

Instructions: Please take a few moments to answer the questions on this reader survey card. We value your assistance, and we'll use the information to help us produce publications which will be meaningful and useful to you. As a way of saying thanks for completing this survey, we'll send you a free subscription to a fascinating newsletter: KODAK *Photonews*. All responses will, of course, be kept confidential.
Thank you!

(1) [2]
(2-7) _____

1. Which of the following categories describes your involvement in photography? (Check all applicable.)

(8) ☐ *Rarely* take pictures.

(9) ☐ *Only* take pictures of "special events" such as birthdays, vacation trips, holidays, celebrations, etc.

(10) ☐ *Frequently* take pictures of family, friends, and normal activities as well as birthdays, vacation trips, holiday celebrations, etc.

(11) ☐ *Very* interested in photography and consider it to be my hobby.

(12) ☐ *Student* in photography.

(13) ☐ *Teacher* of photography.

(14) ☐ *Not a professional* photographer or technician, but use some photography in my job.

(15) ☐ *Part-time professional* photographer or technician.

(16) ☐ *Full-time professional* photographer or technician.

2. What *percentage* of your personal annual income is derived from photography? (Check one.)

(17) ☐ 100%
☐ 50-99%
☐ 25-49%
☐ 1-24%
☐ None

3. Please estimate the amount of film you personally use (not work related) during an average year.

(18-20) 35 mm:_____rolls
(21-23) 120 roll:_____rolls
(24-26) Sheet:_____boxes

4. Approximately how much did you spend during the past year on your *personal* photographic activities (including film, darkroom materials, reference literature, etc.)?

Estimated dollars spent on photography during past year.

(27-31) $_____

5. How many books on photography do you presently have in your *personal* photographic library? (Check one.)

(32) ☐ 3 or less
☐ 4 to 15
☐ More than 15

6. How did you *first* learn about this book? (Check one.)

(33) ☐ A Kodak ad
☐ A magazine or newspaper article
☐ A book review
☐ A salesperson
☐ A friend
☐ Saw it in the store
☐ A teacher
☐ Other

7. How did you obtain this book? (Check one.)

(34) ☐ Bought it in a camera store
☐ Bought it in a book store
☐ Bought it in a discount store
☐ Received it as a gift
☐ Other

8. In what situations will you be using this book most frequently? (Check all applicable.)

(35) ☐ For personal use (hobby)
(36) ☐ At school or during instruction
(37) ☐ On the job (work related)

9. Please indicate your level of satisfaction with this *Kodak Workshop Series* book relative to the characteristics listed. Use a rating scale of 1 to 5. (1 = Very Satisfied, 5 = Very Dissatisfied) Please check appropriate box (#1 through 5) for *each* characteristic listed.

Characteristics of This Book	Very Satisfied 1	2	3	4	Very Dissatisfied 5
(38) "How-To" Workshop Format	☐	☐	☐	☐	☐
(39) Organization of Information	☐	☐	☐	☐	☐
(40) Style of Writing	☐	☐	☐	☐	☐
(41) Photographs	☐	☐	☐	☐	☐
(42) Drawings, Diagrams, and Illustrations	☐	☐	☐	☐	☐
(43) Quality of the Printing	☐	☐	☐	☐	☐

10. Of the following books available in the current *Kodak Workshop Series,* which do you now own or plan to buy? (Check all applicable.)

(44) ☐ *Black-and-White Darkroom Techniques*
(45) ☐ *Photography with Automatic Cameras*
(46) ☐ *Electronic Flash*
(47) ☐ *Using Filters*
(48) ☐ *Building A Home Darkroom*
(49) ☐ *Color Printing Techniques*

11. Of the following *proposed future titles* for the *Kodak Workshop Series,* please indicate the titles that you would be *interested* in owning.

(50) ☐ Close-Up Photography
(51) ☐ Advanced Darkroom Techniques
(52) ☐ Existing-Light Photography
(53) ☐ Nature Photography
(54) ☐ Lenses and Lens Attachments
(55) ☐ Photojournalism
(56) ☐ Antique Photographic Techniques
(57) ☐ The "Art of Seeing" With Your Camera
(58) ☐ Black-and-White Photography
(59) ☐ Basic Lighting Techniques
(60) ☐ Photography for Special Effects
(61) ☐ Setting Up a Home Studio
(62) ☐ Photographing Children
(63) ☐ Portrait Photography
(64) ☐ Travel Photography
(65) ☐ Sports Photography
(66) ☐ Photography With a Video Camera
(67) ☐ Matting, Mounting, and Framing
(68) ☐ Decorating With Photography
(69) ☐ Landscapes and Scenics
(70) ☐ Establishing Your Personal Style
(71) ☐ Backpacking and Photography
(72) ☐ Underwater Photography
(73) ☐ Photography Under Adverse Conditions

Continued on reverse side

12. Which of the following identifies your age group?

(74) ☐ Under 18
☐ 18-24
☐ 25-34
☐ 35-44
☐ 45-54
☐ 55 and Over

13. Which of the following identifies your education? (Check one.)

(75) ☐ High school
☐ Now attending college
☐ Some college
☐ Graduated from college
☐ Graduate level courses or degree

14. Which of the following identifies your gross annual income? (Check one.)

(76) ☐ Under $10,000
☐ $10,000 to $19,999
☐ $20,000 to $29,999
☐ Over $30,000

(77-105) Your Name:_____

(106-135) Address:_____

(136-165) _____

(166-185) City:_____

(186-195) State or Province:_____

(196-201) Zip:_____

(202-211) Country:_____

Thank you for your time and your thoughts. Learning about your photographic interests and needs is an important part of our planning of new publications in the *Kodak Workshop Series*. Your name will be entered for a free subscription to *KODAK Photonews* which is sent out about twice a year.

To mail this survey: Simply fold as indicated. Then tape closed and mail. No postage is required.

(FOLD HERE—TAPE CLOSED)

KODAK WORKSHOP SERIES

CONFIDENTIAL

READER SURVEY

(FOLD HERE—TAPE CLOSED)